BLACK AMERICA SERIES

AFRICAN AMERICANS
OF HARRISBURG

BLACK AMERICA SERIES

AFRICAN AMERICANS OF HARRISBURG

John Weldon Scott and Eric Ledell Smith
with the African American Museum of Harrisburg Inc.

ARCADIA
PUBLISHING

Published by Arcadia Publishing
Charleston, South Carolina

Printed in the United States of America

Library of Congress Catalog Card Number: 2004108188

For all general information contact Arcadia Publishing at:
Telephone 843-853-2070
Fax 843-853-0044
E-mail sales@arcadiapublishing.com
For customer service and orders:
Toll-Free 1-888-313-2665

Visit us on the Internet at www.arcadiapublishing.com

CONTENTS

ACKNOWLEDGMENTS

We would like to extend our sincere gratitude to all who helped us complete this wonderful venture: the entire board of the African American Museum of Harrisburg; the African American Museum of Philadelphia; John Alossi; Melvin "Butch" Baltimore and the Mason family; Barbara Barksdale; Michael Barton; Michael Bowles; Harriet and Paul Braxton; Mary "Mue" Braxton; Katheryn Grigsby Butler; Paul Cannon; Dr. Carolyn Carter; Libby Woolfolk Corbin; Percy Corbin; Leroy Craig; Betty Curtis; Lovette Daniels; Peggi Summers Edmonds; Rev. Billy Gray; Gerri Hamilton; Myrtle Hicks; the staff at the Historic Harrisburg Association; the staff of the Historical Society of Dauphin County, particularly Robert Hill and Warren Wirebach; Mrs. Ruth Hodge; JB Computers; Jeanne Jones; Dr. Dorothy King; Aaron Martin Landis (in memoriam); Lorraine Davis Lawson; Jacqueline Little; John Moody; Dr. Doris Moore; George Nagle, editor of Afrolumens.org; Ann Sullivan Napper; Joyce Parker; Shirley Wells Pierce; Linda Ries and the entire staff of the Pennsylvania State Archives; Aubrey Rose; Inez Scott; the Scott family and friends; Hubert Simpson Sr.; Guy Hassid Stevenson; Sylvia Stevenson; Toni Truesdale; Marshall Waters; Ron Waters; Margaret Watts Williams; and Byron "Jimmy" Wood.

One

EARLY HISTORY

African American history in Harrisburg began with the slave Hercules, who belonged to John Harris Sr. (the father of John Harris Jr., who founded Harrisburg in 1785). The name Harrisburg derives from Harris' Ferry, an outpost located at a spot on the Susquehanna River where the river was only a mile wide and, presumably, a foot deep. Around 1733, it is said, John Harris Sr. was captured by local Native Americans and was tied to a mulberry tree. Just as the captors were about to burn Harris alive, Hercules is said to have walked, swum, or canoed across the river to rescue his master. Hercules, who knew the Native American language, was able to persuade them to let his master go. Harris was so grateful that he granted Hercules his freedom and some land on which he could live after Harris's death.

John Harris Jr. built a mansion that still stands today on Front Street. Many slave owners lived in mansions on Harrisburg's Front Street, which runs parallel to the Susquehanna River. Other members of the Harris family, however, did not follow John Harris Sr.'s example of freeing slaves. In 1780, Pennsylvania passed a gradual abolition law, which said that any slave born after that date had to serve only 28 years. The law also required slave owners to annually register their slaves. According to the 1780 slave register, John Harris Jr. (1726–1791) owned three slaves. They were Jack (age 48), Isaac (age 16), and Frank (age 14). Robert Harris (the grandson of John Harris Sr.) was also a slaveholder. In 1780, he owned a slave named Lucy.

The free African American community of Harrisburg originated with Hercules. In the 19th century, slaves were often referred to as servants, as they did cooking, cleaning, skilled trade work, gardening, and drove carriages for their "owners." Like the city of Philadelphia, Harrisburg had numerous side streets or alleys in which slaves and servants lived in clapboard row houses or shacks. The federal census of 1790 is the first that records the slaveholders in Harrisburg and Dauphin County. According to that census, there were 10 slaveholders in Harrisburg and 80 slave holders in Dauphin County. These people lived on farms or in suburban areas such as Paxtang, where James Crouch and James Cowden owned slaves. Our knowledge of these slaves comes from burial sites in the Paxton Presbyterian Church cemetery, at 3500 Sharon Street in Paxtang. The slaves were buried there because they were members of the church. A late-1800s picture in the church office shows a black girl in her Sunday school finery, worshiping in the church.

In 1790, Crouch had slaves named Rachel, Samuel, Francis, Bodly, Sambo, Phillis, Jack, Issac, Nell, Ket, Nan, Peter, Lucy Lorrett, and George Lorrett. Lucy Lorrett (1747–1847) and her son George (1773–1862) are buried in the Paxton Presbyterian Church cemetery. George fought in the Revolutionary War and made history by becoming one of the first blacks to own land outside of Harrisburg in Dauphin County. George and his mother lived to be the last slaves in Dauphin County. Also

buried in the cemetery is George Washington, a Civil War veteran who came to Harrisburg with the 9th Calvary in the Civil War and stayed with the Crouch family as a servant. In 1790, James Cowden had six slaves: Kate, Lucy, George, Barbara, Sambo, and Dinah. Dinah (1788–1878), often called "Mammy," was known locally for her fine cooking. She is quoted as saying, "Ain't nobody makes a cake like Miss Dinah Jones." When she died, it is said that there were more carriages at her funeral than at funerals for white people, including dignitaries. Dinah's burial site is in the Paxton Presbyterian Church cemetery.

Before the Civil War, some free and some bonded African Americans were working as "servants, employed doing cooking, cleaning, skilled trades work, gardening, bootblacks, rag pickers, and driving horse-drawn carriages." Black people in servitude included the barber James McClintock, chimney sweep John Battis, John "Jack" Fyatts (a servant for the Harris family), and James Pundon. George Findlay worked for James Findlay, the state treasurer who served as Pennsylvania's governor from 1817 to 1820. There was also a growing number of African Americans who owned and operated their own businesses. George and Jane Marie Chester, for instance, ran the Washington Restaurant on Market Street in downtown Harrisburg and were also noted for their catering. After the Civil War, when African Americans faced racism in employment, more would go into business for themselves.

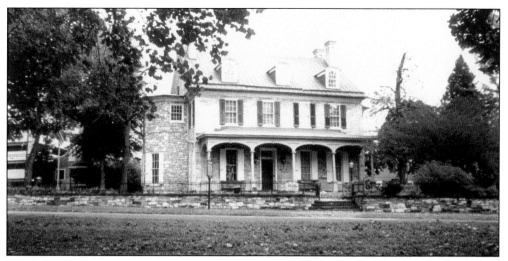

The John Harris–Simon Cameron mansion, on South Front Street in Harrisburg, was built by the city's founder, John Harris Jr. In 1863, Simon Cameron, who was secretary of war during the Lincoln administration, bought the property. The mansion annex houses the Historical Society of Dauphin County.

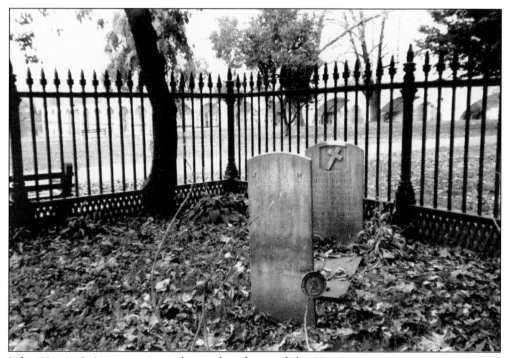

John Harris Sr.'s grave site is located in front of the Harris-Cameron mansion. It was once thought that Hercules was also buried there, but science has proved there is only one grave. The two markers are likely the headstone and footstone.

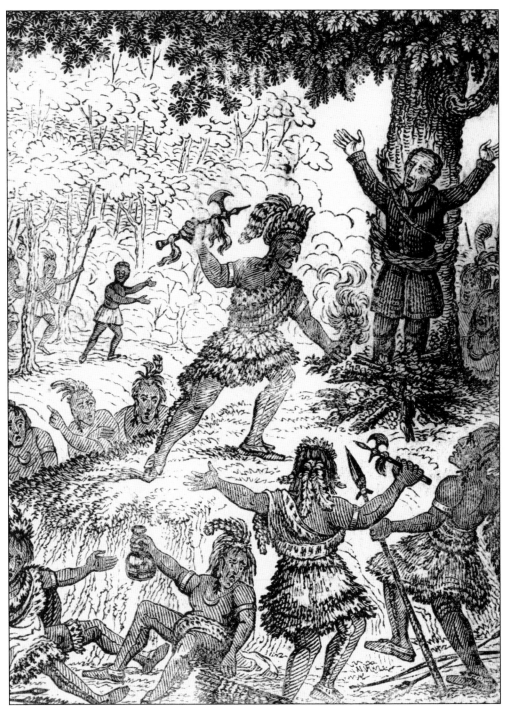

John Harris's manservant, Hercules, brought friendly Native Americans from across the Susquehanna River to help rescue his master from the hostile Native Americans who had abducted him. Harris was tied to a mulberry tree before he was to be killed. This drawing was done by an unidentified author of a German sketchbook. (Courtesy Historical Society of Dauphin County.)

Paxton Presbyterian Church, built in 1740, is purported to be the oldest Presbyterian building in continuous use in Pennsylvania and the second oldest in the United States. African Americans worshiped here.

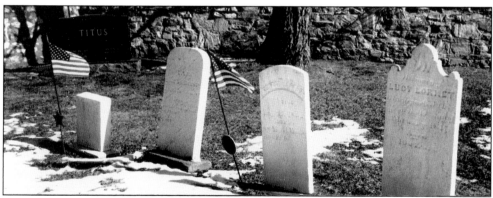

These grave sites at the Paxton Presbyterian Church are those of the supposed last slaves in Dauphin County. On the far left is the grave marker for George Washington, a Civil War veteran who died in 1898. Second from the left is the grave of Dinah, who died in 1878 at the age of 90. It is said that more carriages were seen at her funeral than at any other (black or white) in the area at the time. George Lorrett, a veteran of the War of 1812, died in 1862, and is buried next to his mother, Lucy Lorrett, who was born in 1747 and died in 1847.

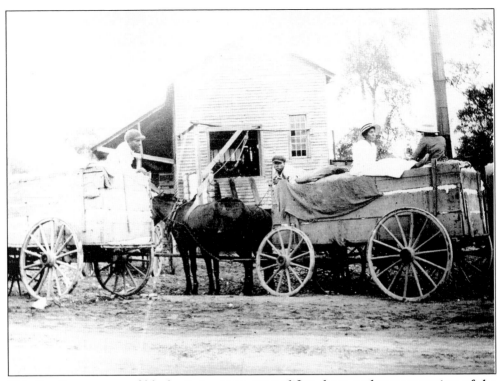

This Southern scene of blacks in a wagon exemplifies dress and transportation of the Civil War era. (Courtesy Pennsylvania State Archives.)

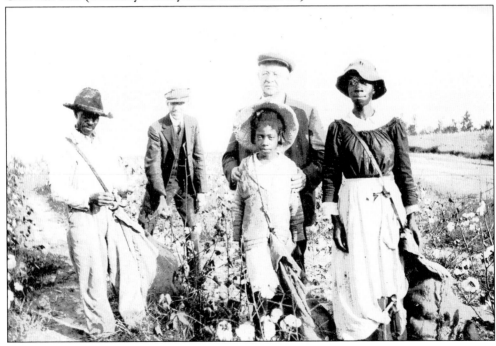

Blacks are shown at work in the fields with their master. (Courtesy Pennsylvania State Archives.)

Slave Surname	Slave Given Name	Owner's Surname	Owner's First Name
Barrick	Charles	Nelson	Henry
Butler	Charles	Brenizer	George
Butler	Hannah	Brenizer	George
Butler	Nathaniel	Brenizer	George
Collins	Harry	Fisher	Thomas
Craig	James	McAllister	Archibald
Craig	Lucy	McAllister	Archibald
Craig (source 22)	Sal(ly)	McAllister	Archibald
Creag	Eliza	McAllister	Archibald
Garret	Middleton	Hughes	Leroy
George	Elmer	Goodman	Simon
Gray	Hetty	McAllister	Archibald
Hall	Mary	Stoner	Samuel
Harris	Jack	Irwin	Matthew
Hoofnagle	George	McAllister	Archibald
Jackson	Simon	Rodgers	Robert
Jenkins	Hallie	McAllister	Archibald
Jenkins	Jack	McAllister	Archibald
Johns	Joseph	?	?
Johnson	Luke	Clemson	John
Lemons	Dinah	Wilson	James
Logan	Benn	Patton	Robert
Lorrett	George	Crouch	James
Martin	Andrew	Richardson	Robert R., Jr.
Martin	John	Hayes	Patrick
Martin	Robert	Hays	Pat
Martin	Thomas	Hays	Pat
McClintock	Jenny	Hendle	Bernard
Miller	Henry	Johns	William
Mitchele	Fleming	Mitchele	Alexander W.
Murry	Maria	McAllister	Archibald
Roach (source 26)	Sam	Duncan	James
Smith	Stephen	Cochran	John
Stewart	John	Neidig	John

The names of Dauphin County slaves and slaveholders *c.* 1790 are recorded on this chart. (Courtesy George Nagle, editor of Afrolumens.org.)

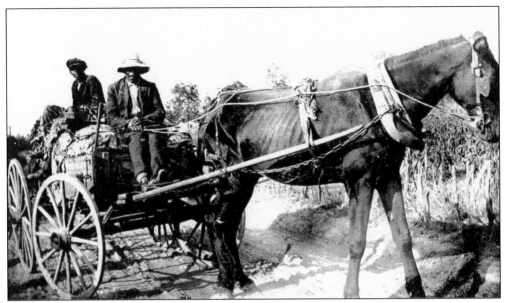

Two unidentified men are seen in a wagon. (Courtesy Pennsylvania State Archives.)

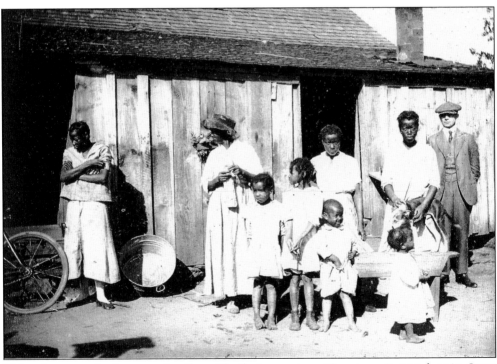

This photograph shows a family with their master. (Courtesy Pennsylvania State Archives.)

Two

THE UNDERGROUND RAILROAD AND THE CIVIL WAR

As the capital city of Pennsylvania and as a major railroad hub only 44 miles from the Maryland state line, Harrisburg was a magnet for abolitionists, fugitive slaves, and Confederate soldiers who were sidetracked by Union forces at Gettysburg. The end of the Civil War brought more change to Harrisburg as African Americans from outside the city, such as William Howard Day, settled here. Day symbolized the emancipated black person who sought equal education and equal political rights. Harrisburg African Americans were in the forefront of social change in the United States in the 19th century. Those affected by this climate of change included women, whites, African American war veterans, fugitive slaves, local citizenry, and abolitionists.

Harrisburg was a center of abolitionism in south-central Pennsylvania. The Harrisburg Anti-Slavery Society was founded on January 14, 1836. More than 100 men and women signed up as charter members of the society. Dr. William Rutherford, whose family was active in the Underground Railroad, is credited with inviting famous abolitionists Henry Lloyd Garrison and Frederick Douglass to Harrisburg in 1847. The two of them spoke on the steps of the Dauphin County Courthouse, where the crowd heckled and threw bricks at them. Garrison and Douglass fled to safety at Wesley Union African Methodist Episcopal (AME) Zion Church, where they later spoke. Other famous abolitionists who visited Harrisburg include John Brown, who had Harrisburg sympathizers who helped him when he was planning the Harpers Ferry raid in early 1859. New York–born William Howard Day, who later made Harrisburg his home, published John Brown's *Constitution* in Ontario, Canada, in 1858.

African Americans were prominent Underground Railroad conductors. Harriet McClintock Marshall (1840–1923), wife of a runaway slave, was a conductor of the Underground Railroad in Harrisburg. Marshall was a member of the Wesley Union AME Zion Church, and she may have hidden fugitive slaves and provided them with food, clothing, and shelter.

Joseph Bustill (1822–1895), a distant relative of singer-actor Paul Robeson, was a schoolteacher and conductor on the Underground Railroad. His letters to Philadelphian William Still, published in Still's book *The Underground Railroad*, describe how Bustill smuggled fugitives out of town and onward to freedom. William "Pap" Jones was a

doctor who masqueraded as a rag merchant to hustle runaway slaves out of town in his wagon. George and Jane Marie Chester owned and managed the Washington Restaurant on Market Street in downtown Harrisburg. They were prominent caterers and reportedly hid fugitives slaves within their building.

A so-called riot in 1850 was Harrisburg's first encounter with the notorious federal fugitive slave law. William Taylor of Clarke County, Virginia, ordered the Harrisburg constable to arrest George Brocks, Sam William, and Billy, whom Taylor said were runaway slaves and horse thieves. "Pap" Jones hired two white abolitionist lawyers, Charles Rawn and Mordecai McKinney, to defend the three blacks. The judge in the case ruled that the horse-theft charges had been fabricated in order to get Pennsylvania authorities to arrest the three men. Although George, Sam, and Billy were found not guilty of horse theft, the judge allowed the slave catchers to seize them, and a riot broke out. Taylor and others were arrested and charged with violation of Pennsylvania's 1847 Personal Liberty Law, which protected African Americans from unlawful kidnapping. The charge against Taylor, however, was later dropped, and blacks who "participated" in the riot served jail time. The lawyers Rawn and McKinney defended other accused fugitive slaves, including Jim Phillips, who was kidnapped in 1852 and taken to Virginia. In a pathetic letter published in Garrison's newspaper the *Liberator*, Phillips pleaded with his wife to help free him. "I can be bought for $900," wrote Phillips. "You must do all you can for your husband." Charles Rawn and Dr. William Rutherford went down to Virginia to buy Phillips's freedom just before he was about to be auctioned off. The newspapers said: "A large crowd of colored people assembled at the train depot to receive Jim. He was placed in a one-horse wagon with his wife and children and escorted through the streets of Harrisburg." Harry Burrs was one of many other runaway slaves who fled to Harrisburg by way of the Underground Railroad.

In 1860, newly elected president Abraham Lincoln came to Harrisburg on the way to his inauguration in Washington, D.C. He was not there long before it was discovered that Southerners planned to hijack Lincoln's train in Baltimore and kill him. With Lincoln in disguise, the black carriage driver Jacob Cumpton drove the president after twilight outside the city limits to catch a secret train to Washington. When the Civil War broke out, Thomas Morris Chester, son of George and Jane Marie, recruited black men for the U.S. Colored Troops. Harrisburg saw much war activity, especially at the military post Camp Curtin, which had a military hospital.

On November 14, 1865, Harrisburg welcomed home the U.S. Colored Troops with a parade led by Thomas Morris Chester. Rev. William Howard Day and U.S. senator Simon Cameron praised the troops. Other U.S. Colored Troops did not survive the war, and many are buried in Harrisburg's cemeteries, including George Scott, George Lee, Ephraim Slaughter, and Horace Bennett.

This Underground Railroad state marker was placed thanks to efforts initiated by the African American Museum of Harrisburg Inc. and the Pennsylvania Historical and Museum Commission in 2000.

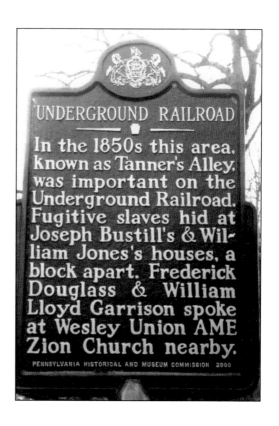

Shown is a portrayal of famous Harrisburg African Americans. From left to right are Calobe Jackson (as T. Morris Chester), Sylvia Stevenson (as Harriet McClintock Marshall), Eric Jackson (as William Howard Day), Joyce Parker (as Jane Chester), John W. Scott (as his grandfather Prof. John P. Scott), and Aaron Martin Landis (as his father, A. M. Landis).

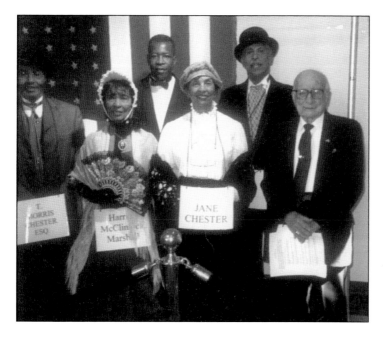

Today, the Rutherford House serves as a museum and senior center. The farmhouses served as a stop on the Underground Railroad, as the Rutherfords were longtime, hardworking abolitionists.

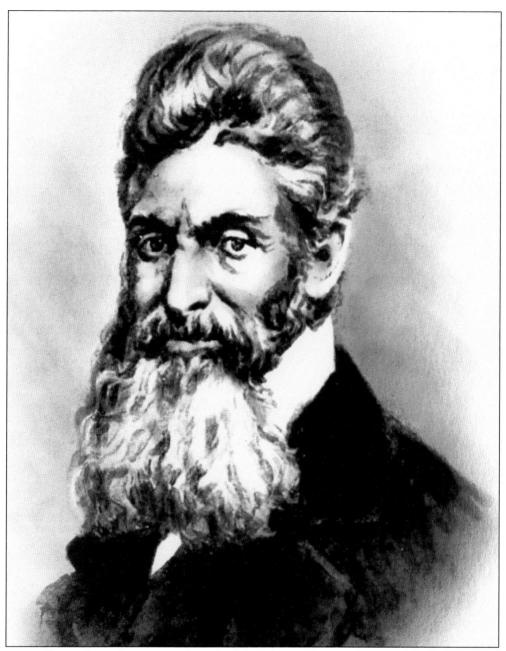

Legend has it that John Brown was in and out of Harrisburg *c.* 1859 (prior to the Harpers Ferry raid) in order to obtain money, supplies, and ammunition. He also met William Howard Day at Oberlin College in Ohio, where Day supposedly helped Brown with some manuscripts. (Courtesy Pennsylvania State Archives, Warren Harder Collection.)

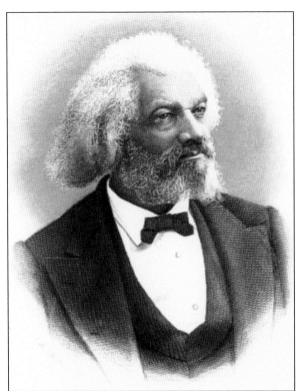

Frederick Douglass—a staunch abolitionist and orator, and later, a federal government official—came to Harrisburg during his speaking tour with William Lloyd Garrison. (Courtesy Pennsylvania State Archives.)

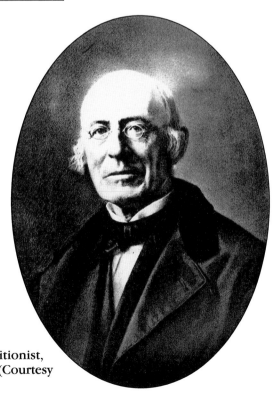

William Lloyd Garrison, avid abolitionist, has relatives in the Harrisburg area. (Courtesy Pennsylvania State Archives.)

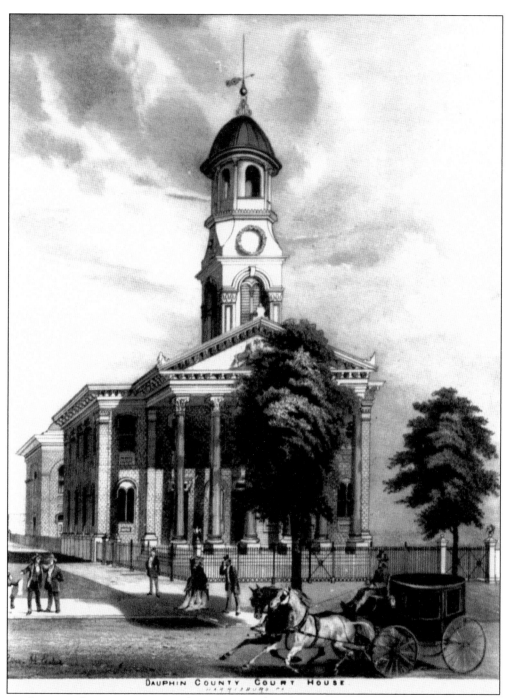

DAUPHIN COUNTY COURT HOUSE

At the Dauphin County Courthouse in 1847, abolitionists Frederick Douglass and William Lloyd Garrison spoke to a raucous proslavery crowd. Both men were escorted away to the Wesley Union AME Zion Church, where Douglass said, "The audience was mostly comprised of our own people and a more interesting array of faces I have seldom seen."

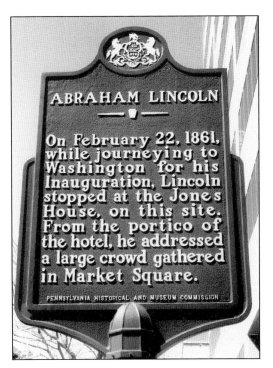

This state marker stands at the site where Abraham Lincoln spoke in Market Square.

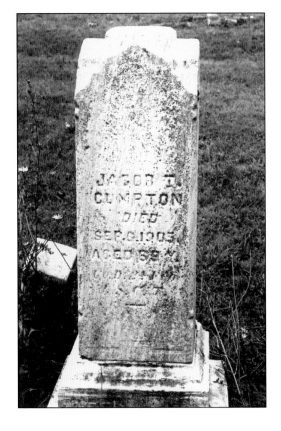

Shown is the grave marker of Jacob Cumpton, an African American who escorted Abraham Lincoln out of Harrisburg and to a train that would carry him to Washington, D.C., for his inauguration. The train left in secrecy after sundown, as there were rumors of a possible assassination attempt.

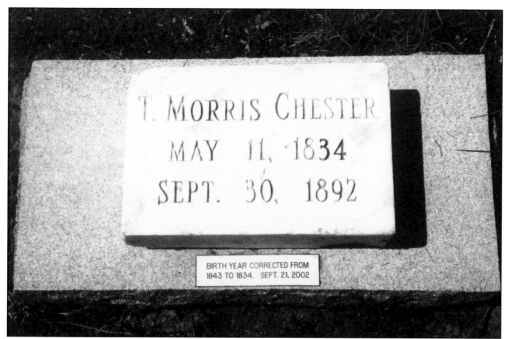

Thomas Morris Chester taught in Liberia and traveled extensively throughout Europe, giving speeches about the plight of African Americans. He also recruited people who were interested in settling a new nation in Liberia.

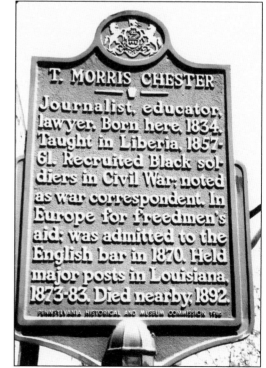

This state marker was rededicated by the African American Museum of Harrisburg. The marker stands at Third and Market Streets near the original Oyster House, an establishment that was run by Jane and George Chester, who catered to Harrisburg commoners as well as elected officials and other dignitaries.

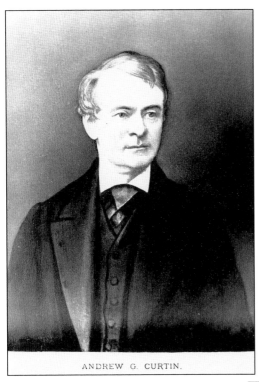

ANDREW G. CURTIN.

On the left is a portrait of Andrew Curtin. The state marker seen below stands on North Sixth Street, near Woodbine. (Left, courtesy Pennsylvania State Archives.)

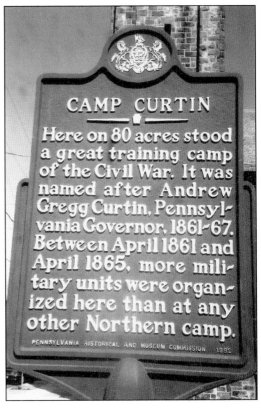

CAMP CURTIN

Here on 80 acres stood a great training camp of the Civil War. It was named after Andrew Gregg Curtin, Pennsylvania Governor, 1861-67. Between April 1861 and April 1865, more military units were organized here than at any other Northern camp.

PENNSYLVANIA HISTORICAL AND MUSEUM COMMISSION 1992

Camp Curtin War Camp, a military camp in the northern United States, was an official hospital that operated from 1861 to the end of the Civil War. The camp was named after Andrew Curtin, Pennsylvania governor from 1861 to 1867. The monument of Camp Curtin (right) and statue of Governor Curtin (below) are on North Sixth Street, which was at the outskirts of Harrisburg in the Civil War era.

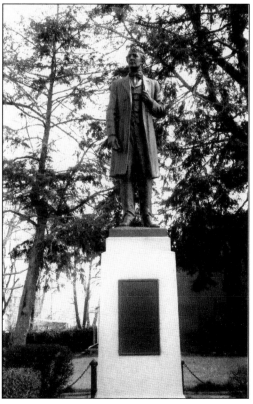

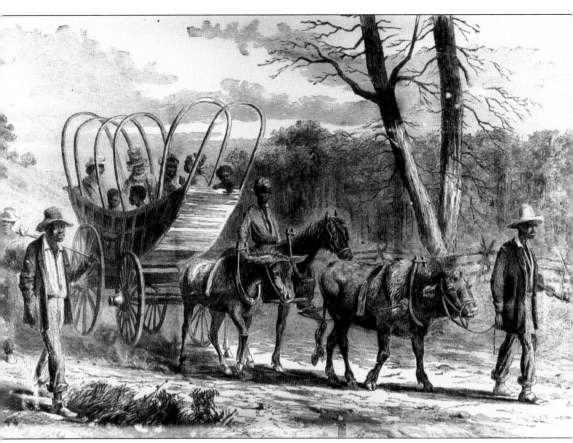

Blacks are on the move with their belongings, presumably after the Emancipation Proclamation went into effect on January 1, 1863. (Courtesy Pennsylvania State Archives, Warren Harder Collection.)

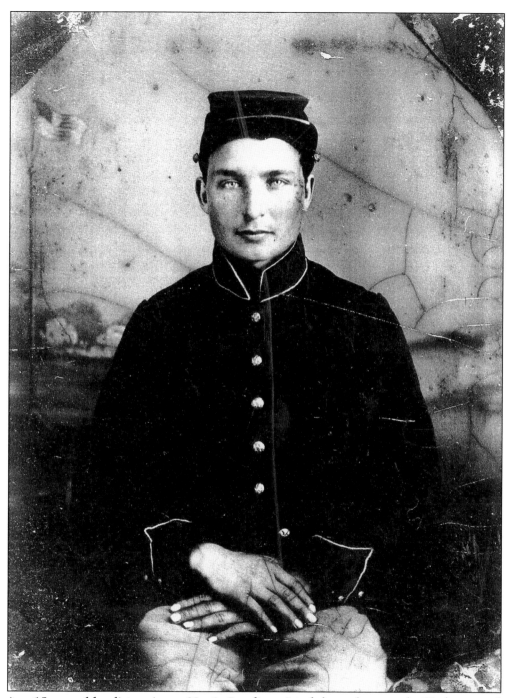

As a 15-year-old enlistee, Aaron Martin Landis assisted three slaves to the Underground Railroad. Later, in Harrisburg, Landis met with and befriended Harry Burrs, one of the slaves he had helped. (Courtesy Aaron Martin Landis collection.)

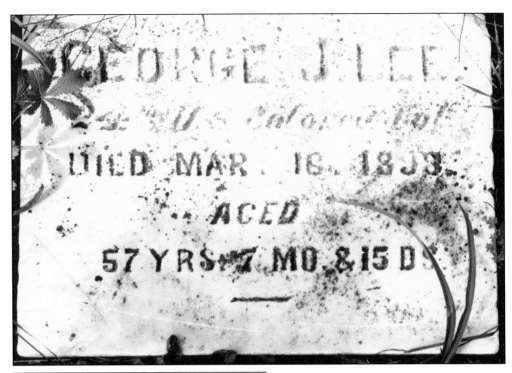

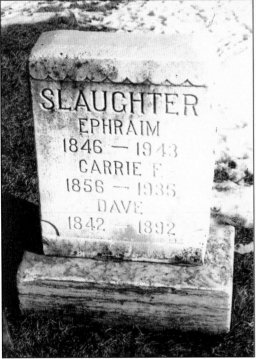

Shown on these two pages are a few of the Civil War veterans' grave sites in Lincoln Cemetery: George Lee (above) was a member of the 24th Regiment of the U.S. Colored Troops; Ephraim Slaughter (left) was Harrisburg's last surviving Civil War veteran.

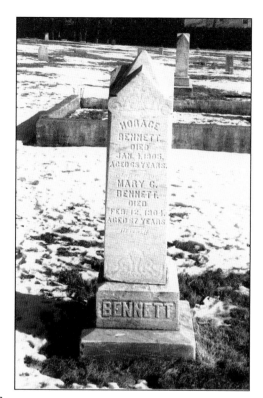

Horace Bennett (right) was a friend and neighbor of George Scott (below). The two served together in the 24th Regiment of the U.S. Colored Troops. Scott is the author's great-grandfather.

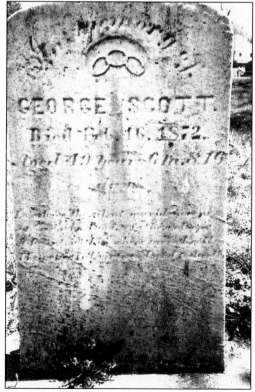

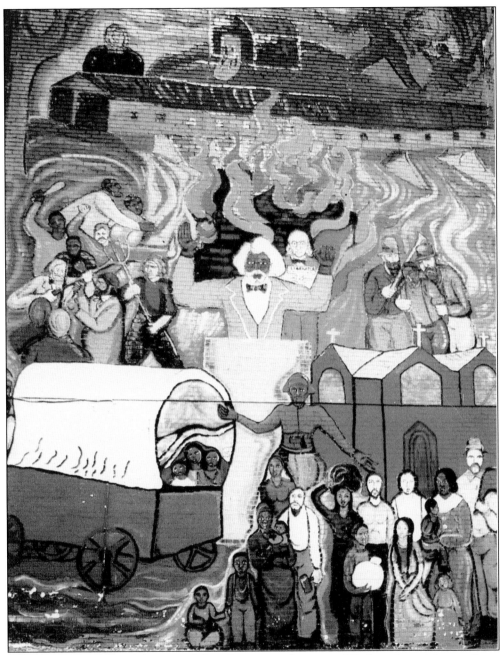

Toni Truesdale created this mural that depicts Underground Railroad participants from Harrisburg and other areas. Among those depicted in the mural are "Pop" Jones and Harriet McClintock Marshall. (Courtesy Toni Truesdale and Neighborhood Center of the United Methodist Church.)

Three

EARLY CHURCHES AND CEMETERIES

The church has been a stalwart factor in the lives of African Americans from the beginning. From the creation of the Wesley Union AME Zion Church in a log cabin at Third and Mulberry Streets in 1816 to its founding in 1829 and the construction of its brick building in 1836, the church has played a significant role in the development of Harrisburg's African American community and the city at large. From its beginning, Wesley has served as a place of worship, a school for children and adults, a distribution center, and a refuge for African Americans fleeing the South in search of freedom and a better way of life. Harrisburg was a crossroads, as Wesley served as a stop on the Underground Railroad.

Wesley's congregation consisted of very distinguished families in the community, including those of Rev. Dr. William Howard Day, Harriet McClintock Marshall, John P. Scott, George and Jane Chester, Bustill, and Popel families. The church also hosted many distinguished national figures, such as as Frederick Douglass, William Lloyd Garrison (who spoke to a rather cold reception in downtown Harrisburg), and W. E. B. Du Bois.

The church also served as a focal point for meetings of the African American community. In 1837, Wesley hosted people from all over at an organizational meeting for the Anti-Slavery Society. In 1848, the church hosted the Statewide Convention for Colored Citizens. The early newspaper *Home Journal* and others often refer to disturbances in the "colored" neighborhood, where a meeting at the church sparked some violent attacks by white intruders. Stories have been told of slave hunters being warded off by African Americans around the church to defend people (some free and some fugitive slaves) from being returned to their owners in the South. In 1885, documents relating to the centennial celebration of Dauphin County listed some figures relating to the African American citizenry of Harrisburg. At that time there were six African American churches and two African American schools. The two schools (Lincoln, with 60 students, and Calder, with 50) were later replaced by Wickersham School. The Hercules Centennial Association and Club consisted of 6 committee members and 100 club members participated in the centennial parade. Also in the parade were 20 members of the Cornett Band of Steelton. (This information can be found in T. R. McIntosh's *Harrisburg's Role on the Trail to Freedom,* published in 2002.)

The Bethel AME Church, founded in 1835, was the second African American place of worship in Harrisburg. In 1857 Wesley Union AME Zion and Bethel AME formed a coalition and successfully petitioned the state legislature to provide space for a grave site suitable for burial of African American citizens.

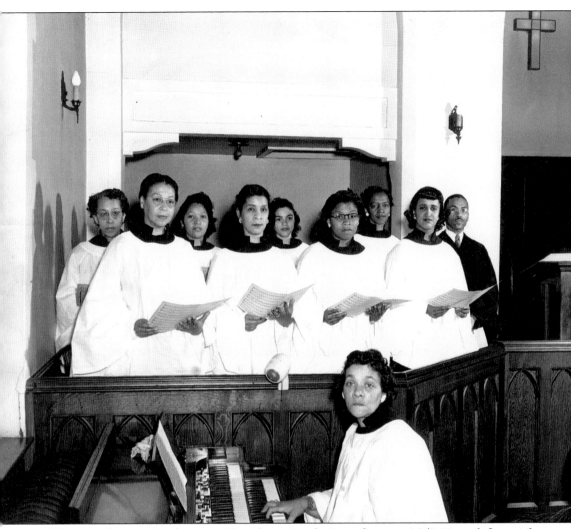

The Capital Street Presbyterian Church senior choir performs *c.* 1947. From left to right are the following: (at front) organist Eva Braxton; (first row) Naomi Brock, Mrs. Irving, Maggie Burnett, and Etta March; (second row) Mary Myers, Adelaide Smith, Mary Braxton, Annie Carroll, and Pastor Rev. H. Garnett Lee. (Courtesy Mary Braxton.)

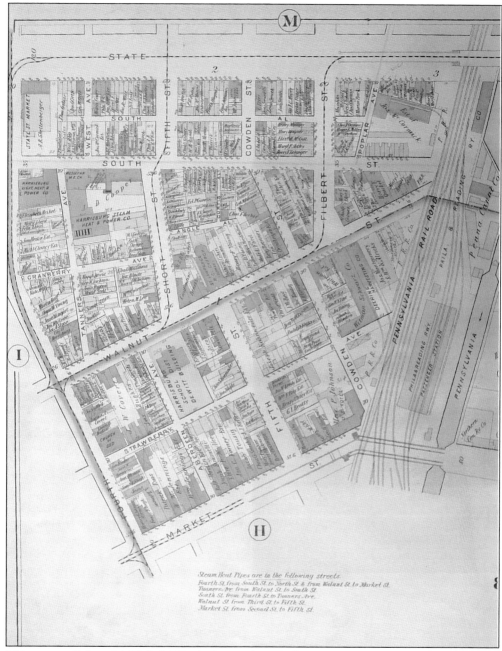

This map of the old Eighth Ward shows the Wesley Union AME Zion Church at the corner of Tanner Avenue and South Street. Familiar names, such as Scott, Bennett, and Popel, can be found among the property owners. (Courtesy Historical Society of Dauphin County.)

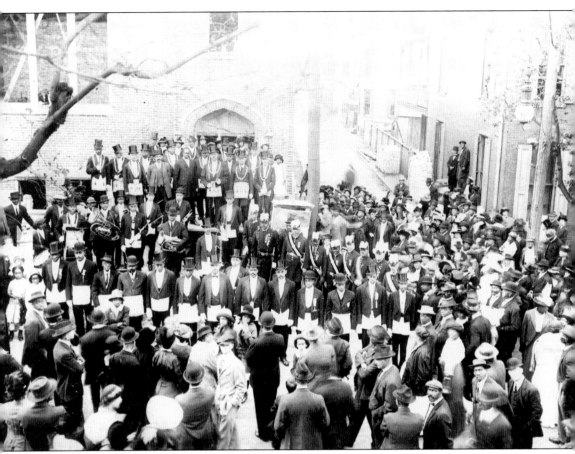

Pictured is the laying of the cornerstone for the Wesley Union AME Zion Church, at Forster Street and Ash. The ceremonies, held on Sunday, October 18, 1914, included a parade that featured the Mason band and the Grand Lodge of Colored Masons, led by state grand master Prof. John P. Scott. Also visible in this view are members of the Grand Chapter of Odd Fellows in their official garb.

Wesley Union AME Zion Church is the oldest African American church in Harrisburg.

The present-day Wesley Union AME Zion Church stands at Fifth and Camp Streets. The pastor is Rev. Jimmy Allen Thomas.

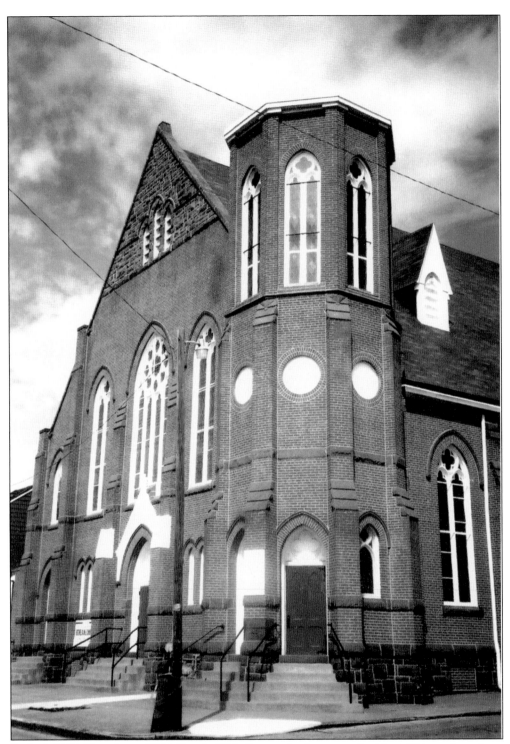

Bethel AME Church, at 1721 North Fifth Street, is the second-oldest African American church in Harrisburg. The original edifice stood on North Sixth Street until it was devastated by fire in 1995. The pastor today is Rev. Lawrence C. Henryhand.

Market Square Presbyterian Church
stands in downtown Harrisburg.

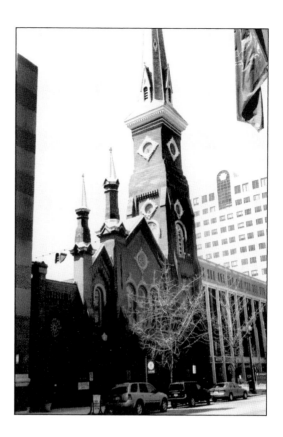

Capital Street Presbyterian Church is at 1401 Cumberland Street. The church was established in the late 19th century, when some African Americans split from Market Square Presbyterian Church to form their own congregation.

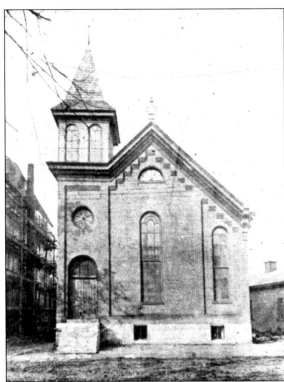

The original Second Baptist Church, the first African American Baptist church in Harrisburg, stood on Cameron Street above Market Street. (Courtesy Mary Braxton.)

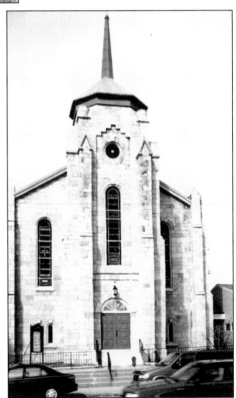

The present-day Second Baptist Church, led by pastor Rev. A. J. Briley, is located on Forster Street.

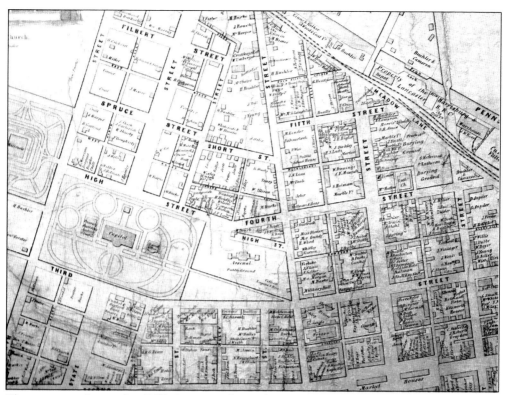

The cemetery located at Fifth Street and Meadow Lane (upper right) includes the grave sites of German Lutherans, Presbyterians, and African Americans. (Courtesy Historical Society of Dauphin County.)

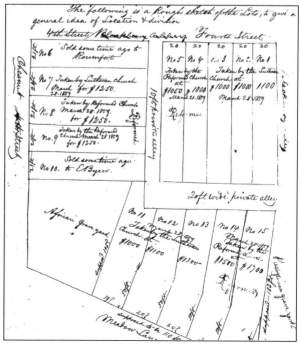

This sketch shows an African American cemetery at the lower left. (Courtesy Historical Society of Dauphin County.)

This monument honors Dauphin County African Americans who served in all wars. Its construction was made possible by the Benevolent Society, composed of Jane Chester, Laura Robinson, Catherine McClintock (Harriet McClintock's mother), Elisha Marshall, Benjamin Foote, James Stocks, James Greenly, George Douglass, and Joseph Popel.

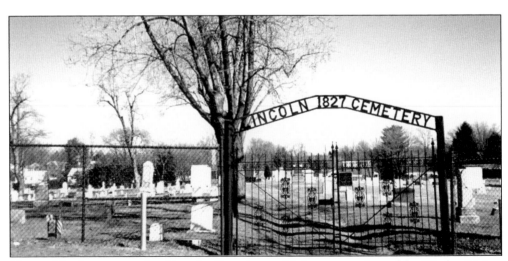

Pictured is the gate to the Lincoln Cemetery, which was purchased by Wesley Union AME Zion Church in the 19th century. Many prominent African Americans are interred in the cemetery.

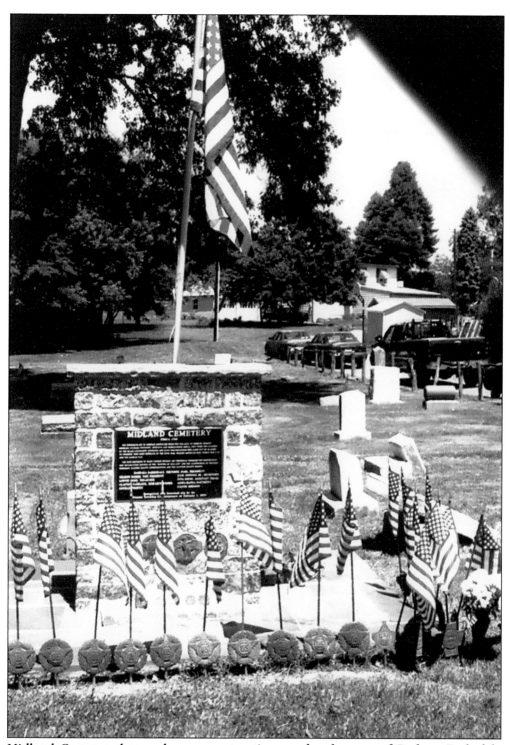

Midland Cemetery has undergone restorations under the care of Barbara Barksdale and the Friends of Midland. African American veterans from many different wars are interred here and at the William Howard Day Cemetery, in Steelton.

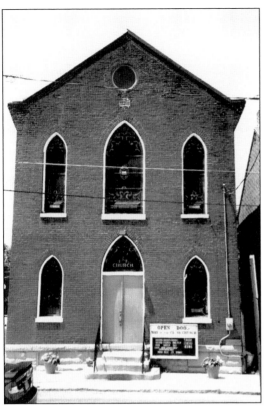

The old Harris AME Church is one of the longest-standing African American churches in Harrisburg. It is located on Marion Street, across from the Broad Street Market.

The present-day Harris AME Church is at 915 North 17th Street. The pastor is Rev. Donald Brantley.

Four

DR. REV. WILLIAM HOWARD DAY AND EARLY EDUCATORS

In 1817, Thomas Dorsey founded the first school for "colored children, both free and bound" in the Wesley Union AME Zion Church in Harrisburg, shortly after the church was organized. Prior to 1827 only private education was available. Many parents (both white and black) could not afford to send their children to those schools, which cost $1 per three-month quarter. William C. Jenks served as first-grade teacher in a room in the county courthouse after the state legislature authorized the first public schools.

In 1860, the two wards in Harrisburg were made into six, and each ward controlled its own educational affairs. Four high schools had been started in 1836, two in each of the original two wards (North and South), one for girls and one for boys. Consolidation of the wards came in 1867–1869, and thereafter control of the schools was transferred from the wards to the city of Harrisburg.

A newspaper article in the African American newspaper *Home Journal* reports that M. H. Layton had three students ready for entrance into the boys' high school. In 1879, Spencer P. Irvin was principal of the school at Fifth and North Streets. Three "colored boys" were admitted, but only two (John P. Scott and William Howard Marshall) were the first of their race to graduate from the high school (in 1883). John P. Scott, the highest-ranking student in academics, presented the salutatorian speech at graduation. The title of his speech was "Stand for Yourself." At that time, the principal was William H. Wert. After graduation, both Scott and Marshall began teaching at the Wickersham and Calder Buildings, where black children attended classes. In 1910, those schools were located in neighborhoods where much of the African American population resided. There was also a school named after William H. Day, and the Downey School, which was racially integrated for both students and teachers.

The junior high schools (Edison and Camp Curtin) and senior high schools (William Penn and John Harris—both constructed in 1926) were not segregated, but no African American teachers were evident until the late 1950s.

The Harrisburg School District's directory for the 1910–1911 school year identified the following African American educators: Calder Building (Sixth Ward), William H. Marshall (principal) and Catherine Payne (teacher); Downey Building (Seventh Ward), Margaret I. Blalock (teacher); Day Building (Eighth Ward), M. H. Layton (principal)

and Clara E. Reed, Helen Taylor, and Ida E. Brown (teachers); Wickersham Building (Eighth Ward), Anne V. Crowl (principal) and John P. Scott, J. Henry Williams, and R. Emma Coleman (teachers).

The 1918 directory recorded the following: Calder Building, John P. Scott (principal) and Catherine Lewis, Sarah J. Cooper, and Mildred Williams (teachers); Downey Building, Isabel Saul and Georgiana Potter (teachers); Wickersham Building, M. H. Layton (principal) and Emma C. Miller, Ruth Parsons, Harriet Harrison, Ida E. Brown, H. P. Payne, and J. Henry Williams (teachers).

Other early African American pioneers in Harrisburg's school district included the following: Joseph Bustill, Charlotte Weaver (Chester), Priscilla Young, Edith Dennis, Mary Denison, Margaret Marshall, Jane Blalock Charleston, Annie Carmond, Ruth Parsons, Mabel Jackson, Kathryn Johnson, Marian Brown, Helena Oxley, Clara Robinson, Sue Alexander, Estelle Scott Johnson, "Pappy" Williams, Helene Broome Spradley, Myrtle Hicks, Miss Condell, Mrs. Grigsby, Mrs. Briscow, Mildred Mercer Cannon, Miss Price, Mrs. Brooks, Bertha Terry, Bessie Braxton, Elizabeth Baker, Izetta Lee, Dorothy Duffin, Sarah Williams, Jean Brown Leftridge, Miss Johnson, Valera Precious Coles, Mattie Sue Brown, Colonel Lyles, Matilda Hanson Clark, Margaret Wilson Leonard, Marjorie Winfield, Pauline Miller Brown, Clara Brown, Louise Armstead Barksdale, Mary Warfield, Margretta Reeves Craig, Hazel Johnson, Evelyn Johnson Cotton, Debra Craig, and Nelly Lawson.

Two teachers outside the classroom included Ella Frazier (from the Phyllis Wheatley YWCA) and Lawrence Williams (from the Forster Street Young Men's Christian Association).

Later administrators included the following: Dr. Charles Crampton, physician and athletic trainer at William Penn High School; Dr. Richard Brown, school board director; James H. Rowland Sr., school solicitor and cofounder of Harrisburg Area Community College; Aubrey Howard, administration; Rev. Clarice Chambers, school board director; and Geraldine Wells Smith, school board director in Carlisle.

Pioneering educators in later years included the following: Karl Hope, the first African American secondary teacher; Alfreda Askew Johnson, the first female African American secondary teacher; Judith Hill; Dr. Barbara Baton; Delores Acey Jones; Nathan Waters; James Parker; Joyce A. Scott Parker; Larry Jack; John Wesley Gumby; Leroy Robinson; Jackie Jones Brown Jackson, the first African American secondary teacher in Steelton; Marjorie Penolver; Teresa DeRamus; Mary Ann Brown Watts; Dr. Andrews; Larrie McLamb; Marshall Layton; George Love; and Juanita Harper.

University professors included the following: Estelle Scott Johnson, the first African American professor in a state college system (Indiana State, later Cheyney University); Robinson Parsons (Texas Southern University); Ed Temple (Tennessee State University); Shirley M. Baton (University of New Mexico); Neil Simpson (East Stroudsburg University); William Rowland (Syracuse University); John Weldon Scott (Cheyney and Shippensburg Universities); Dr. Elizabeth Clark Lewis (Howard University); Phyliss Proctor Toms (New York University system); James Hill (Shippensburg University); Mr. Reed (Shippensburg University); Dr. Willie Malloy; Dr. Carol Flynn Malloy (University of North Carolina); and Dr. Glenda D. Price, president of Mary Grove College (Detroit, Michigan).

Members of the Pennsylvania Department of Education included the following: Fanetta Gordon; Dr. George Love; Larrie McLamb; Karl Hope; Dr. Nathaniel Gadsen; Mrs. Betty Jean Hall; and Jean Wright.

One African American member of the Pennsylvania Department of Health was Jeanne E. Jones (dental hygienist).

Superintendents included Dr. Willie Malloy, Yvonne Echols Hollins (Central Dauphin Schools), and Audrey Hill Utley (Middletown).

Rev. Dr. William H. Day resided in a house on Briggs Street when he lived in Harrisburg. (Courtesy Pennsylvania State Archives.)

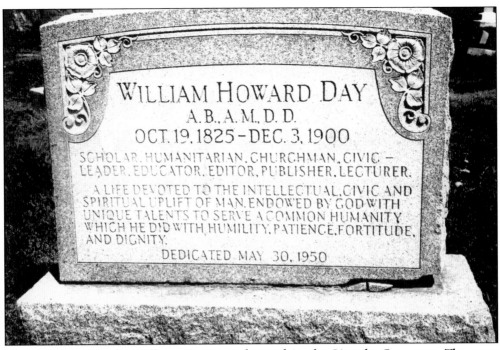

The grave marker for William H. Day is located in the Lincoln Cemetery. The state marker stands at the entrance to the William H. Day Cemetery, in Steelton.

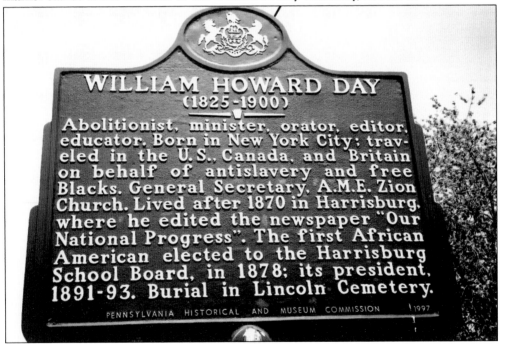

Morris H. Layton prepared William H. Marshall and John P. Scott to be the first two African Americans to graduate from high school in Harrisburg (1883). Scott achieved the highest academic honors of his class.

Rev. William H. Marshall, son of H. McClintock Marshall, helped form the Bethel AME Church and was a staunch activist in the community. (Courtesy Historical Society of Dauphin County.)

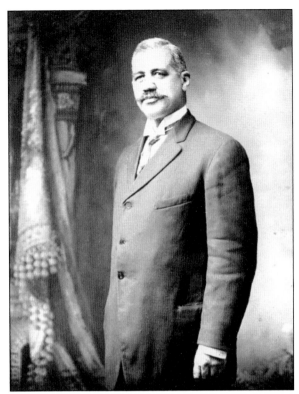

In a speech at his high school graduation, salutatorian John P. Scott said, "The power of self-support is possessed by each individual and upon its use or abuse must each depend for success or failure." (Courtesy Calobe Jackson.)

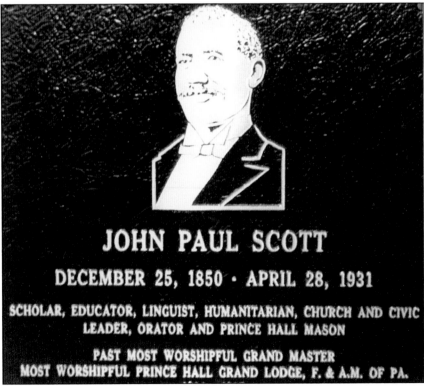

JOHN PAUL SCOTT

DECEMBER 25, 1850 · APRIL 28, 1931

SCHOLAR, EDUCATOR, LINGUIST, HUMANITARIAN, CHURCH AND CIVIC
LEADER, ORATOR AND PRINCE HALL MASON

PAST MOST WORSHIPFUL GRAND MASTER
MOST WORSHIPFUL PRINCE HALL GRAND LODGE, F. & A.M. OF PA.

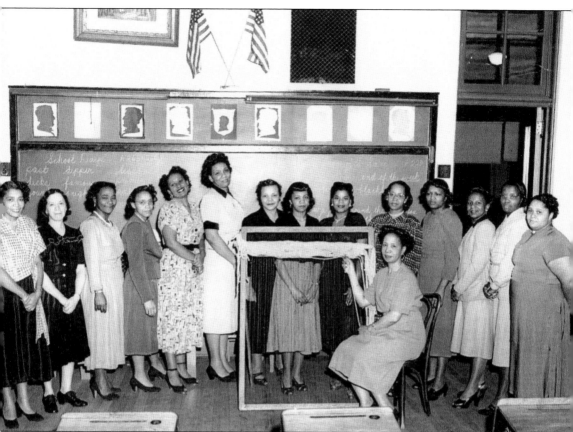

Pictured at the Calder Building in February 1951 are teachers and PTA members. The teachers include Katherine Condol (second from left), Myrtle Hicks (third from left), Izetta Whitaker (fifth from left), and Mary Warfield (seated at the loom). Clara Robinson (seventh from left) is a school principal.

The building that formerly housed the Technical High School (Tech High) and, later, Harrisburg's city hall, now serves as an apartment complex.

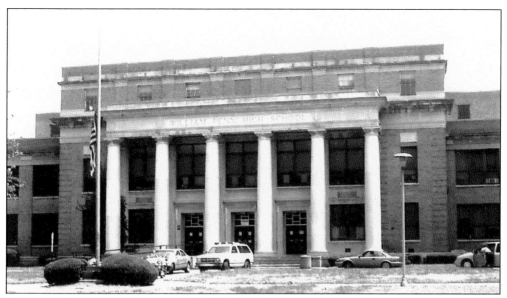

Seen is William Penn Senior High School, in the Uptown section of Harrisburg.

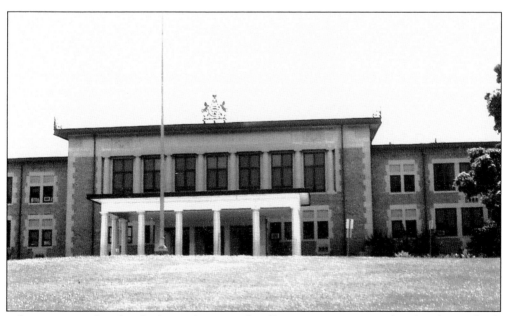

John Harris High School (shown here) and William Penn Senior High School were built *c.* 1926. They are still active educational institutions.

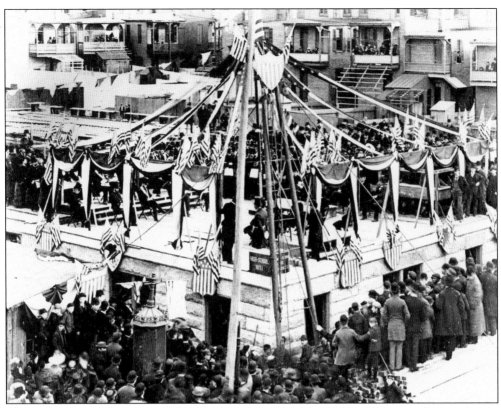

The cornerstone for Central High School was laid in 1891. (Courtesy Pennsylvania State Archives.)

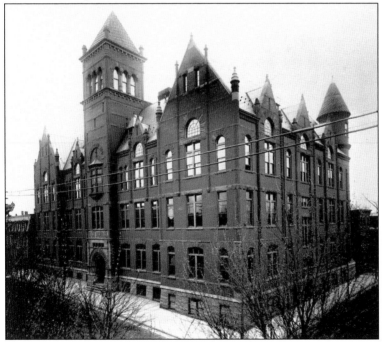

This photograph of Central Girls High School was taken in 1921. (Courtesy Pennsylvania State Archives.)

Mildred Mercer Cannon graduated with Mary Watts in 1921. Cannon later taught with Prof. John P. Scott.

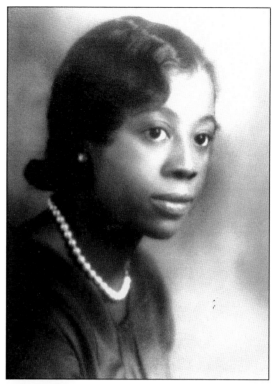

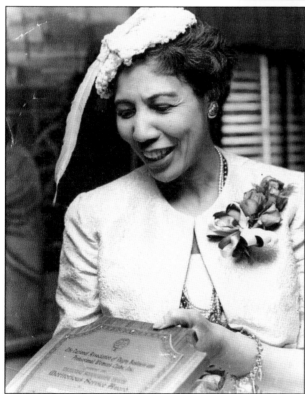

Estelle Scott Johnson, daughter of Prof. John P. Scott, was the first African American to teach in the state college system. She also taught at Cheyney, where she retired.

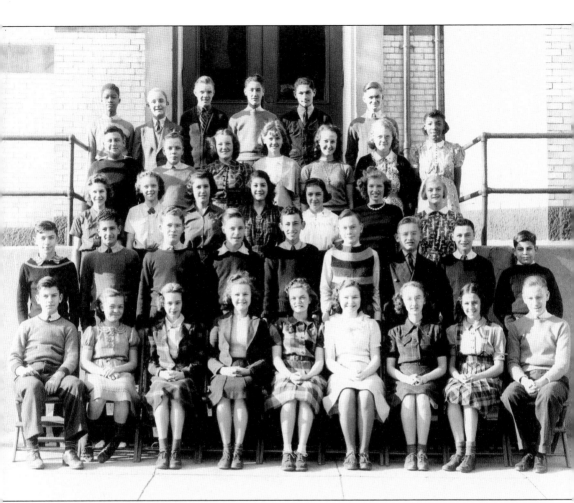

Karl Hope, first student on the left in the last row, is in the ninth-grade graduating class at Camp Curtin Junior High School located at Sixth and Woodbine Streets. This picture was taken from the Forrest Street side near Sixth Street. (Courtesy Karl Hope Estate and Myrtle Hicks.)

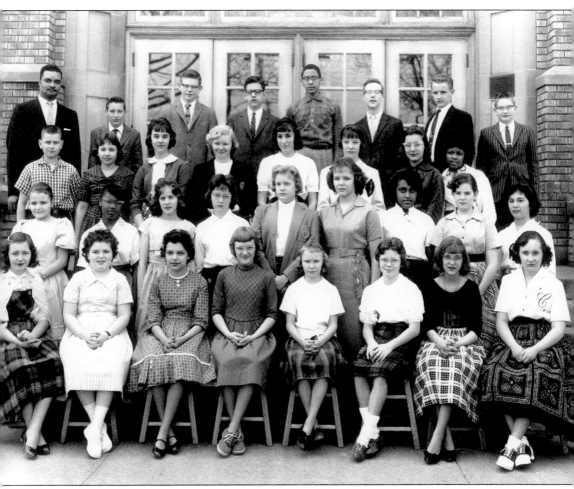

Karl Hope (first from the left in last row) is shown as a teacher at the Edison Junior High School. In the late 1950s, he became the first African American male to be hired as a secondary school teacher in Harrisburg. (Courtesy Karl Hope Estate.)

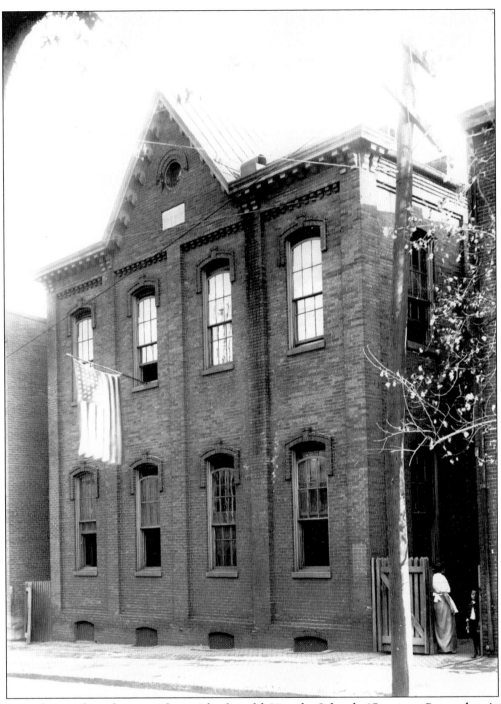

A teacher and student stand outside the old Lincoln School. (Courtesy Pennsylvania State Archives.)

Five

NEIGHBORHOODS

Early Harrisburg city directories show that African Americans lived in many areas of the town. The most popular place was the Eighth Ward. The Capitol Complex expansion (1912–1919) demolished most of the ward and displaced the people who lived there, including many African Americans. Also displaced were many institutions, such as the Wesley Union AME Zion Church, the Corona Hotel, the meeting place for the local Odd Fellows organization, and the Young Men's Christian Association (YMCA). The Eighth Ward was known by such infamous names as the Bloody Eighth and the Tenderloin District.

When the German and Presbyterian churches moved their burial plots near their churches, more space was provided for further expansion of the city. Other neighborhoods were soon created in various parts of Harrisburg.

Maclay's Swamp, or Maclayburg, was north of the Harris ferry along the Susquehanna River. In 1857 William Verbeke acquired the farmland of Robert Gilmore, and that area became what was known as Verbeketown, around Herr and Boas Streets.

Historic Midtown, the area between Forster and Verbeke from the river to Third Street, was one of the oldest residential areas of the city, dating from the mid-1800s. The area known as Hardscrabble, or Hart's Rabble, grew up around the river, where raft crews and people working in other river-related businesses were provided with activities for their enjoyment. Such activity sometimes caused raucous situations. Legend tells us that some people from this part of town may have taken part in the Underground Railroad.

Market Square was the hub of the city in the late 19th century, as it is today. The Market Square Market was active until 1889. The section known as the Capitol Complex (although devoted to state government) had a residential area called Judytown, where various ethnic groups resided. They included Jews and African Americans, as well as people of Irish and German descent. The African American section on Third Street was referred to as Bull Run. Other areas of note were Camp Curtin, the Uptown section, and Allison Hill (named for its founder, William Allison).

Shipoke is an interesting district. At its beginning, it was populated by a mix of ethnic groups. In the early 1900s, it became the major focus for the City Beautiful project.

As Harrisburg expanded, new construction often displaced family residences, more often African Americans than other groups. New neighborhoods developed and changed the population patterns of the city. Places such as Bellevue Park and Schreinerstown began to develop as neighborhoods, but few African Americans were permitted to purchase property in the Bellevue area for many years.

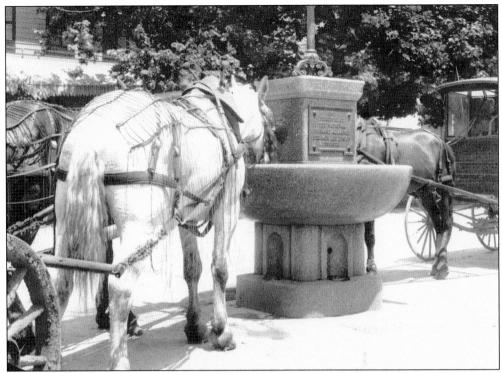

The water fountain at Derry and Mulberry was used by fire companies and horse-and-buggy drivers. It still stands today. (Courtesy Pennsylvania State Archives.)

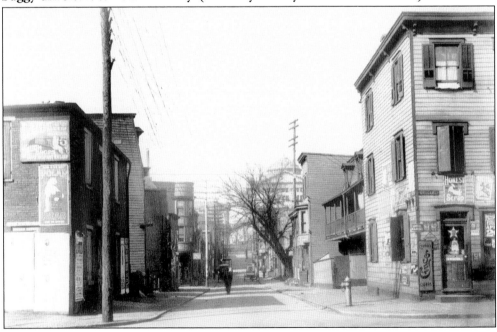

This is a view down Filbert Street in the old Eighth Ward. Parson drugstore, with its protruding two-story facade, can be seen at the center of the left side of the street. (Courtesy Historical Society of Dauphin County.)

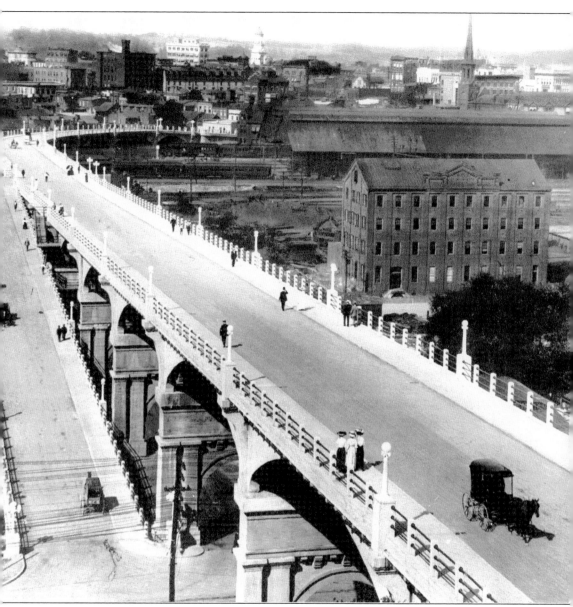

Seen is the Mulberry Street Bridge with a ramp from Cameron Street. (Courtesy Pennsylvania State Archives.)

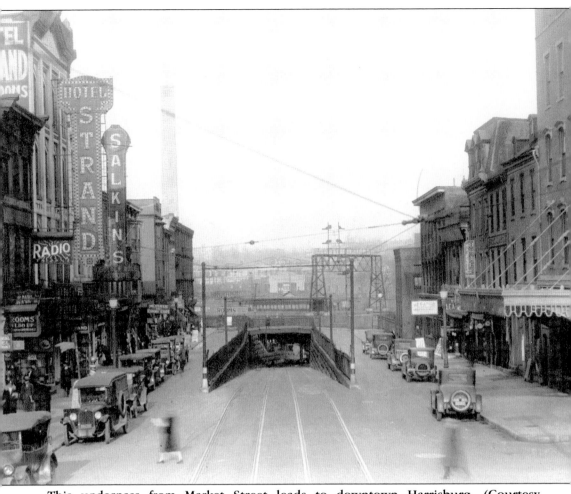

This underpass from Market Street leads to downtown Harrisburg. (Courtesy Pennsylvania State Archives.)

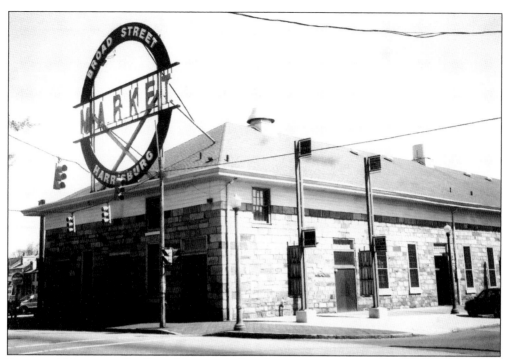

In an oral history on the Broad Street Market, A. Martin Landis recalls: "[In the] good old days I remember the Broad Street Market at Susquehanna and Calder. I pulled a wagon to the curb, they would come with a basket, and we would go deliver to their homes." This store is one of the oldest continuously operating markets in the country.

Summit Terrace is in Allison Hill, where African Americans moved after being displaced by a a state-sponsored expansion project. Prof. John P. Scott raised his five children at 139 Linden Street. Other families who lived in the area included the Grigsbys, Braxtons, Brooms, and Andersons.

Harrisburg resident Marshall Waters (left) remembers: "Like I say, the 12th Street Park once had three teams, Midget, Junior and Seniors. They had a full day at the park."

Morrison Park (once called Sunshine Park and 12th Street Park) is named in honor of Justice Clarence Morrison.

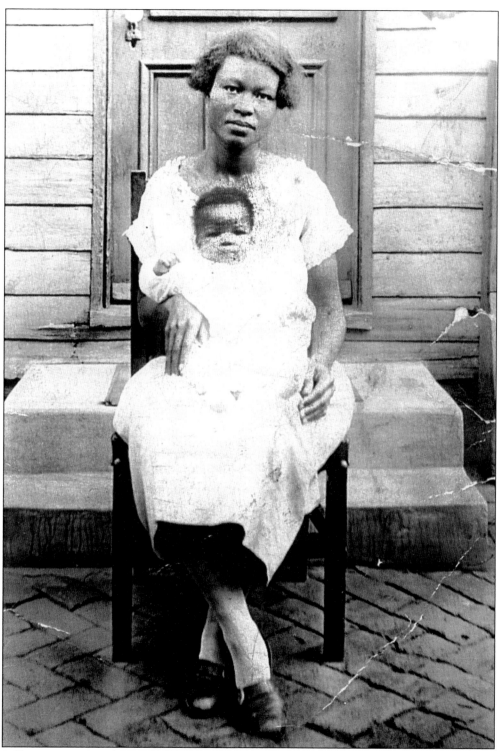

Sallie Mae Davis Wily is seen *c.* 1925 on Boas Street, in the Uptown section, with baby Luscious Daniels. (Courtesy Lovette Daniels.)

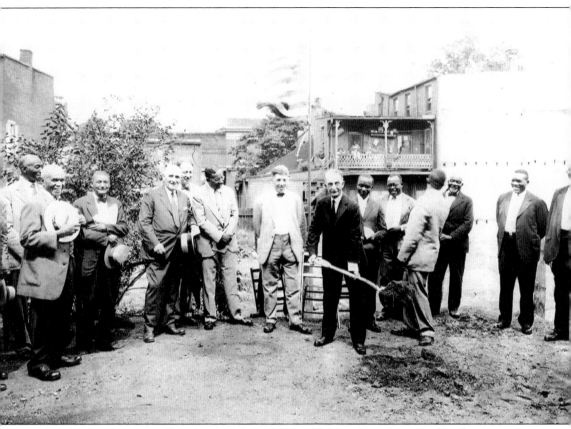

Pictured at the groundbreaking of the YMCA on Forster Street are Dr. Charles Crampton (sixth from the left), George Winters (third from the left), and other Harrisburg dignitaries. (Courtesy Historical Society of Dauphin County.)

Six

EMPLOYMENT, BUSINESS, AND ORGANIZATIONS

Slavery in the North was quite different from slavery in the South. Slaves often lived in the household and sometimes lived away from the house, except on farms and in other rural settings. The changing seasons of the North afforded slaves the chance to perform tasks other than the typical (or stereotypical) work in the cotton fields. Many slaves who were freed remained faithful to the families for whom they had worked; they stayed on but received wages for their duties.

Jacob Cumpton, who worked as a buggy driver for the Cameron family, once drove a disguised Pres. Abraham Lincoln to catch a train in order to avoid a rumored assassination attempt. More-common duties for slaves included cooking, cleaning, landscaping, taking care of children, and performing general household maintenance. Slaves also hauled goods, delivered messages, and did the shopping. Slave responsibilities varied in the rural areas, which at that time were not very far from Harrisburg itself. Some slaves served as field hands, smiths, carpenters, coopers (one who repairs barrels and casks), whitewashers, chimney sweeps, seamstresses, caterers (as in George and Jane Chester's establishment), and barbers. One man had a traveling well, selling water from the Susquehanna River. Later, African Americans secured jobs as laborers for the construction of buildings, the Pennsylvania Canal, and other major projects in the city. An African American community grew as its members became more educated and affluent; capitalizing on their unity and contacts enabled them to open their own businesses in their own neighborhoods.

One section of the Uptown neighborhood had developed a large population at the dawn of the 20th century. Forster Street, Boas Street, and Sixth Street (also known as Commonwealth Avenue) were full of businesses, churches, organizations (such as the Odd Fellows and the YMCA), restaurants, and tearooms. The area also included many residences for people of other ethnic groups. Forster Street was named after Gen. John Forster, who fought in the War of 1812. Boas Street seemed to be named after Frederick Boas's son Daniel, a famous politician and businessman.

Some of the important sites in Harrisburg included the Booker T. Washington Hotel (675 Boas Street), the Lillian Ball House (928 North Sixth Street), the Dr. Morris Layton home (930 North Sixth Street), the Curtis Funeral Home (1000 North Sixth Street), Bethel AME Church (1008 North Sixth Street), the Calobe Jackson Sr. barbershop (1002 North Sixth Street), the Jackson House Hotel and Restaurant (1006 North Sixth Street), the Capital Street Presbyterian Church (at Elder and Forster), the Second Baptist Church (420 Forster Street), the Dr. Charles Crampton

office and residence (600 Forster Street), the Hooper Funeral Home (604 Forster Street), Wesley Union AME Zion Church (610 Forster Street), and the YMCA (614–628 Forster Street).

In the *Pennsylvania Negro Business Directory* (published by James H. W. Howard and Son in 1910), it is recorded that African Americans had held their rights and "kept pace" with their white counterparts. Some of the prominent people at that time included Sylvester Jackson, Charles White, and Harry Burrs, who were in insurance and real estate. Others, such as James Polston, Neal Powell, Taylor Robinson, John Ferrel, and Lewis Togan, operated their own businesses in carting and contracting. Other notable people included funeral director Joseph Thomas, W. Justin Carter (who ran the Douglass Cooperative Company), and Dr. Charles Crampton. W. H. Craighead and J. W. Craighead published the *Advocate Verdict*. Other African American newspapers included *Our National Progress* (published by Dr. William H. Day in the late 1800s), the *Home Journal*, and the *Steelton Press* (published by Peter Blackwell in Steelton).

In the 1950s, another displacement occurred in the Uptown section at Sixth, Boas, and Forster Streets. A state-sponsored expansion project demolished the entire district from Sixth to Seventh Streets, causing other neighborhoods to be established and new businesses to open.

The Forster Street Young Men's Christian Association (YMCA) was a significant group in the African American community of Harrisburg. Its formation began near the end of World War I, when Harrisburg's African Americans looked at the successes of the War Camp Community Service (WCCS) and found that the experiences benefited the nation and the men who served. A group of men was assembled by the illustrious C. Sylvester Jackson on Sunday, November 2, 1919, to consider plans to take over the work of the WCCS. The group included W. Justin Carter Sr., Augustus Stewart, Lennon Carter, Dr. Stephen J. Lewis, Dr. Morris H. Clayton, Dr. Edwin H. Parson, Harry Burrs, Walter J. Hooper, C. Sumner Brown, Robert Jackson, Forrest Miller, and William Chambers.

The International Committee of the YMCA planned to organize a branch in Harrisburg for "colored men and boys." In 1920, the YMCA had 620 new members. The YMCA's first site was the Odd Fellows hall, at Briggs and Cowden Streets; the second was the Corona Hotel, at Broad and Wallace Streets; the third was the Holy Cross parish hall, at Cowden and Forster Streets. The Forster Street YMCA was constructed c. 1933. (This information was taken from Hubert Clark Eicher's *The Harrisburg Young Men's Christian Association: A Century of Service,* published in 1955.)

The Phyllis Wheatley Branch of the Young Women's Christian Association (YWCA) was also inspired by the War Camp Community Service. Because of the historic importance Phyllis Wheatley had to African Americans and to the nation as a whole, her name was adopted for the YWCA. Ella Frazier arrived in Harrisburg in 1927 and was named second executive director of the local Wheatley Association. Frazier was a strong defender of the youth and could be seen day and night talking to the children and parents of all the neighborhoods. She was highly respected throughout the community by both races. Frazier involved the girls in many activities, but was especially keen on etiquette and skills to get a job, such as office work and homemaking. Athletics were also stressed, along with parlor games.

The first site of the YWCA was at 800 Cowden Street. In documents associated with the organization's 25th-anniversary celebration (in 1945), membership was listed at 1,100. Many Harrisburg natives still remember the basketball games, splash parties, and chaperoned dances. At the dances, both Frazier and Lawrence Williams were always in attendance, along with other parents and interested adults.

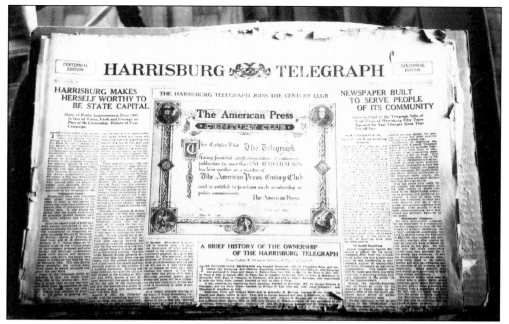

A centennial edition of the *Harrisburg Telegraph* was published on September 7, 1931. The *Telegraph* was known to have treated African Americans more justly than the competitor in using language less maligning to the race.

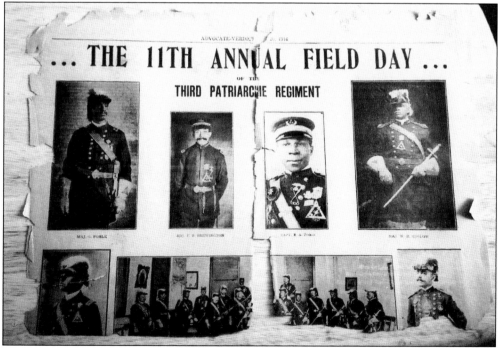

Shown is the May 26, 1916 edition of the *Advocate Verdict*. The paper, which cost 3¢, was "Generally Recognized as Central Pennsylvania's leading Negro Journal." It was published by Frank Robinson, Charles Crampton, Robert Nelson, Frank Jefferson (editor), and Dr. S. J. Lewis (associate editor).

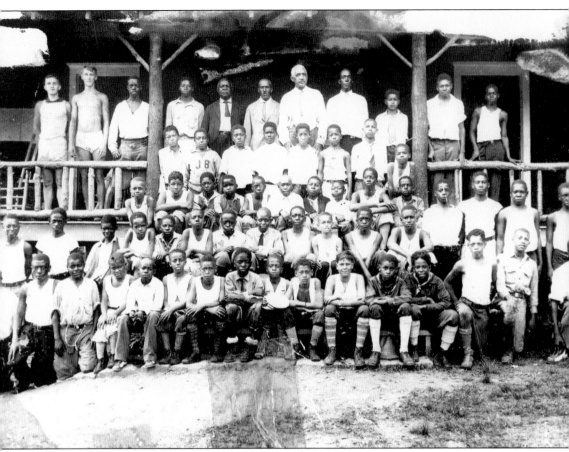

Members of the Forster Street YMCA are shown at Camp Shikalimmy in 1928. From left to right are the following: (first row) M. Williams, Carl Johnson, Dan Paige, Vance Johnson, Leroy Weathers, Lou Gray, C. Madden, two unidentified, ? Brown, K. Nickens, B. Brown, unidentified, M. Miller, Bill Scott, and M. Summers; (second row) Max Johnson, N. Cole, L. Webb, H. Geary, two unidentified, ? Dunlap, unidentified, Bud Primas, unidentified, H. Clemens, and Bruce Johnson; (third row) T. Hemsley, J. Craighead, R. Simpson, ? Jackson, C. Finley, C. Coslley, James Carrouth, M. Middletown, ? Summers, H. Sloane, J. Providence, Edgar Gibson, and R. Webb; (fourth row) "Popsicle," John Brown, Snooks Butler, Tom Hill, two unidentified, James Scott, and Delaney Robinson; (fifth row) two unidentified, Robbie Lewis, H. Providence, two unidentified, Prof. John P. Scott, unidentified, Bus Carter, Bill Simpson, and unidentified. (Courtesy Mrs. Dan Paige Sr.)

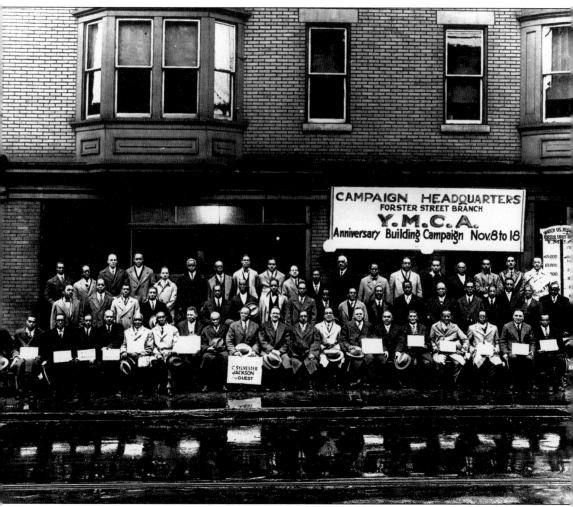

Fund-raisers for the Forster Street YMCA are pictured in November 1929. From left to right are the following: (first row) P. Jefferson, E. Fox, F. D. Gholston, J. Fitzugh, P. Moore, R. Posey, B. Jeffers, W. Hooper, A. Barbour, C. Jackson, R. DeFranz (director), Dr. Charles Crampton, W. Bond, Dr. A. Marshall, J. Clifford. G. Winters, R. Cooper, George Powell, W. Spotwood, and L. Robinson; (second row) G. Dews, F. Jackson, W. Harris, G. Chase, W. Boynton, J. Baker, E. Taylor, A. Green, J. Armstrong, E. Banks, H. Robinson, N. Brown, S. Parsons, J. Ross, A. Jones, H. Green, R. Waters, and B. Gray; (third row) D. Williams, C. Williams, W. Glover, Reverend Jenkins, A. Frye, V. James, W. Shields, ? Reynolds, T. Nelson, ? Potter, C. Thomas, S. Ellison, J. P. Scott, E. Whitten, R. Johnson, C. Dent, W. King, D. Robinson, S. Simpson, and A. Fields. (Courtesy Historical Society of Dauphin County.)

The Forster Street YMCA is shown before demolition. (Courtesy Historical Society of Dauphin County.)

Pictured is the present-day YWCA in the Mount Pleasant Hill neighborhood.

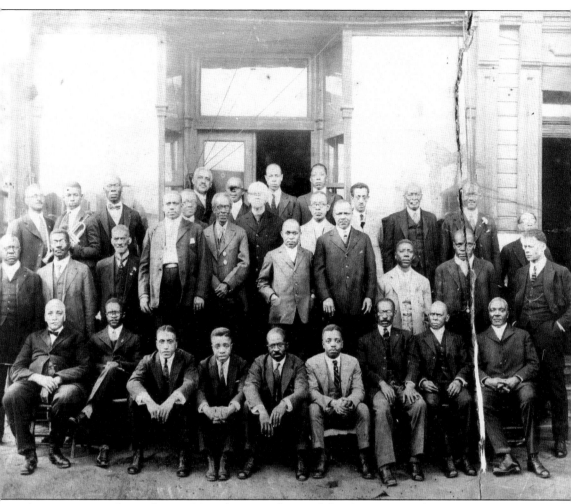

A prayer group from the YMCA is shown in front of the Corona Hotel in 1929. Among the men pictured are B. Valentine, P. Vennie, E. Fulton, J. Baker, C. Jackson, Prof. John P. Scott, "Pop" King, R. Burden, E. Derring, A. Denny Bibb, T. Blake, S. Stewart, Reverend Duffin, Dr. R. Speaker, Harry Burrs, W. Bond, W. Hooper, L. Craig, T. Carter, W. J. Carter, Reverend Smith, ? Posey, Rev. W. Hicks. (The men were identified by Fred Carrington.)

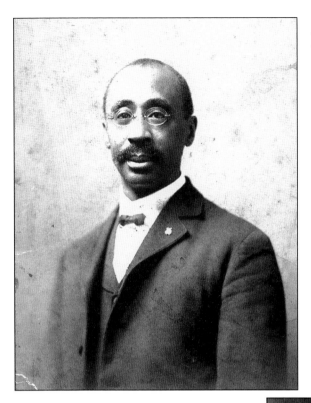

Joseph Thomas was the first African American funeral director in Harrisburg.

Joseph Thomas (right) bought land in Susquehanna Township in the late 1880s and willed it to his sister-in-law, Miriam Waters, who later willed it to her children. In 1975, one of Miriam's children, Marian Waters Scott, constructed a house on the property with her husband, William, and son John. Today the house serves as the Scott residence, which is situated next to the home of Marian and Bill's daughter Joyce, who was parceled a piece of the property from B. U. and Miriam for her wedding gift.

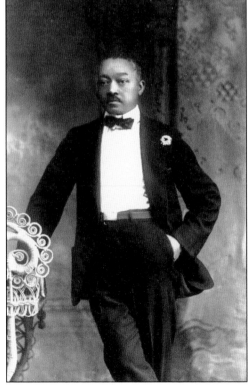

WM. HILL. JOS. L. T[

HILL & THOMAS,

FUNERAL DIRECTOR[

OFFICE 445 E. State St., Harrisburg, Pa.

☞ All Calls Promptly Attended To. ☜

Everything First-Class. **Terms Reasonable.**

Pictured is the business card of Hill and Thomas funeral directors.

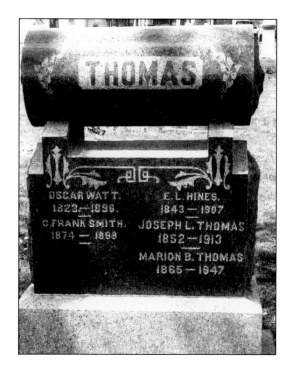

The grave site of Joseph and Marion
Thomas is in the Lincoln Cemetery.

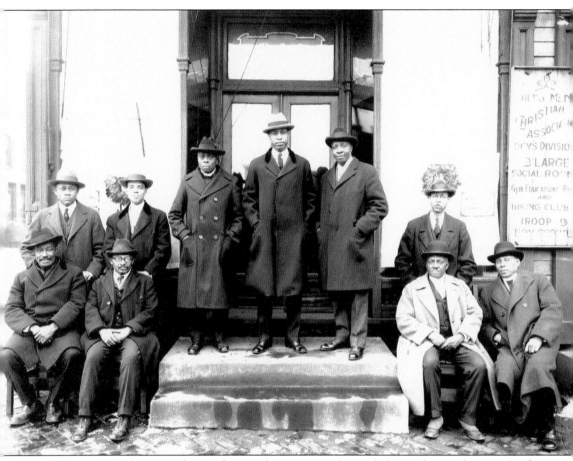

Ten men are shown in front of an early YMCA in the Eighth Ward. Standing at the far right is Dr. James E. T. Oxley. (Courtesy Historical Society of Dauphin County.)

This house on Capital Street was said to have been used for rag collection. Legend has it that early residents of the house assisted with the Underground Railroad.

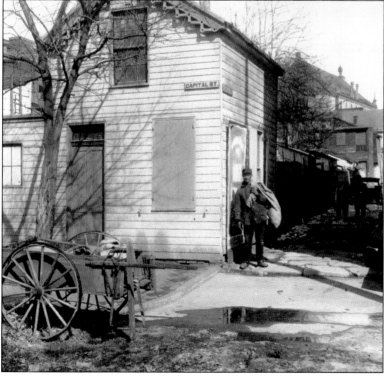

An unidentified ragman is shown buying and selling rags on Capital Street. (Courtesy Pennsylvania State Archives.)

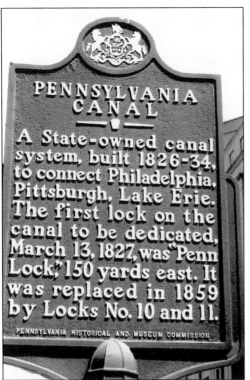

Pictured is the state marker for the Pennsylvania Canal, which employed many African Americans from Harrisburg and some recent arrivals from the South during the "Great Migration."

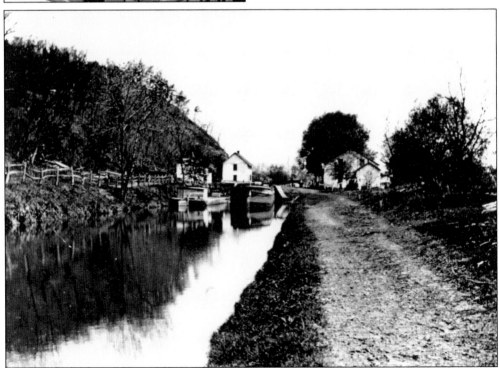

This photograph offers a view of the Pennsylvania Canal. (Courtesy Pennsylvania State Archives.)

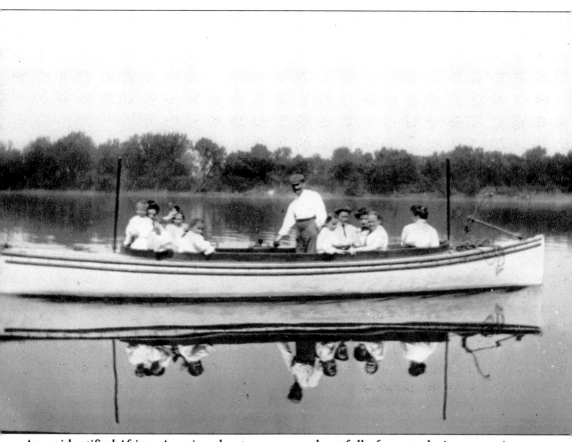

An unidentified African American boatman rows a boat full of guests during an outing on a waterway near Harrisburg. (Courtesy Pennsylvania State Archives.)

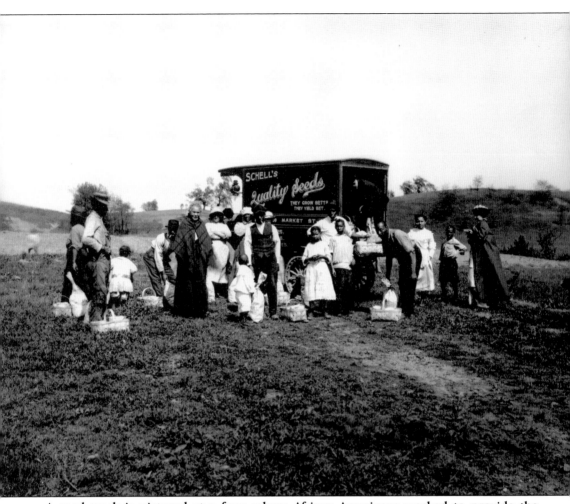

A seed truck is pictured at a farm where African Americans worked to provide the Schell seed store with merchandise. It appears that they have picnic baskets. (Courtesy Historical Society of Dauphin County.)

We instruct in Automobile and Aeroplane construction
We train you to become expert Aviators, Chauffeurs and Mechanics

FLYING DRIVING REPAIRING

AUTOMOBILE AND AEROPLANE MECHANICAL SCHOOL

Aviation Field and Training Quarters

PRACTICAL TRAINING AND MACHINE SHOP 44 N. CAMERON ST

OFFICE—22 N. CAMERON ST Bell 1710 Dial 2476

HARRISBURG PA

Felton's Flying School was located on North Cameron Street. Felton also gave flying exhibitions in the area.

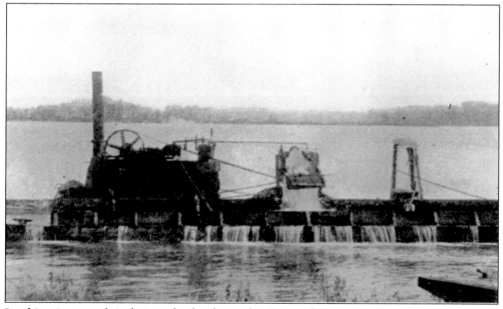

In this view, coal is being dredged on the Susquehanna River. In an oral history, Marshall Waters said that children would gather dropped pieces of coal in wagons and take them to their homes for heating. (Courtesy Pennsylvania State Archives.)

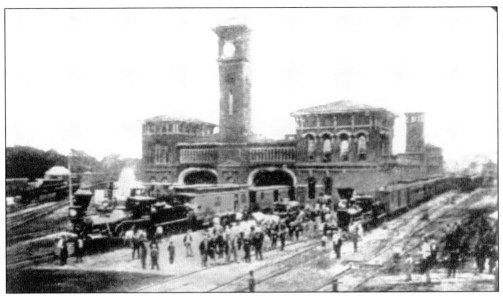

Shown are Penn Station (above) and the Seventh Street Station (below). (Courtesy Pennsylvania State Archives.)

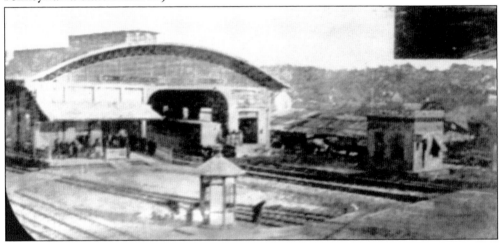

Cyrus Randolph (right) and wife Luisa Randolph are pictured here. Members of the Randolph family worked for the Hoffer/Detweiler family, at 21 N. Front Street, for many years, beginning in the 1860s. Luisa Randolph was born in 1860 and was five years old when slavery was abolished. Lula Randolph (not pictured), Cyrus's sister, worked with the Hoffer/Detweiler family until her death in 1960. (Courtesy Peggi Summers Edmonds.)

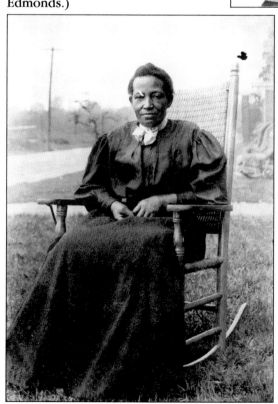

Sina J. Cooper Summers is shown at left. Pictured below is Sina's husband, Arnold C. Summers Sr. (Courtesy Peggi Summers Edmonds.)

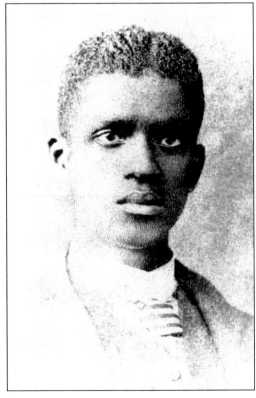

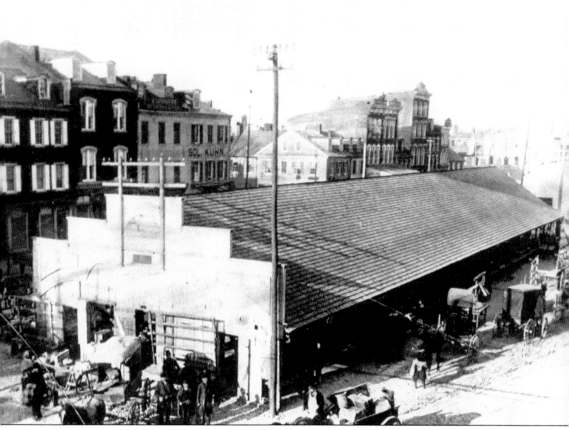

The Market Square Market, at Second and Market Streets, was active until the late 19th century. The area now has the Reverend Dr. Martin Luther King Jr. City Government Center, the Hilton Hotel, Market Square Presbyterian Church, and banks and offices. (Courtesy Pennsylvania State Archives.)

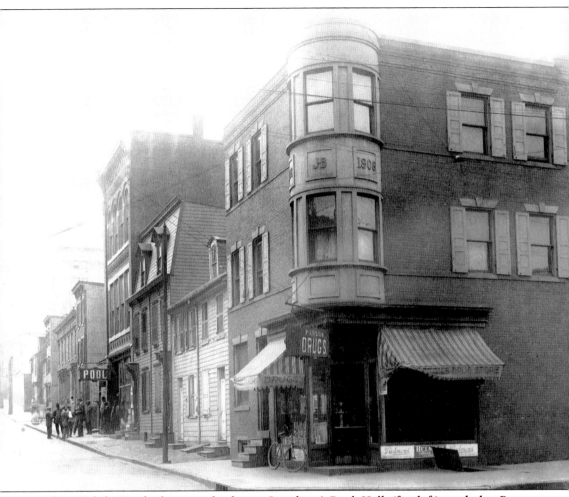

This Eighth Ward photograph shows Strothers' Pool Hall (far left) and the Parson drugstore (center). The pool hall was owned by William Strothers, who was also the founder and owner of the Harrisburg Giants, a Negro League baseball team. (Courtesy Historical Society of Dauphin County.)

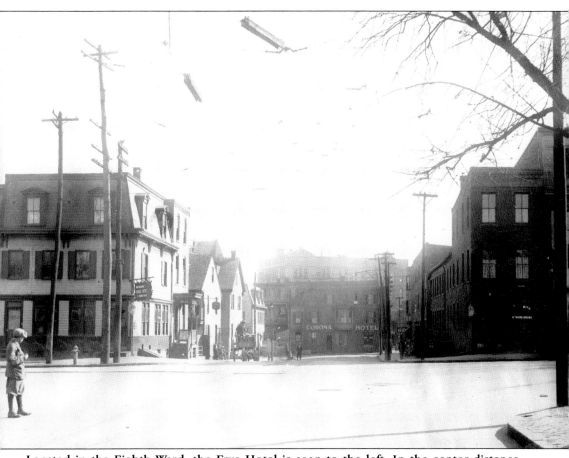

Located in the Eighth Ward, the Frye Hotel is seen to the left. In the center distance is the Corona Hotel, which served as a meeting place for churches, Odd Fellows, and other organizations. (Courtesy Historical Society of Dauphin County.)

Waiters and waitresses pose in the Plantation Room at the Penn Harris Hotel in 1930. From left to right are the following: (first row) Mary Fisher, Laura Thomas, Mary Russell, Inez Scott, Josephine Sheppard, and Ann Moore; (second row) Esther Moore, Gladys Mason, Penrose Johnson, Emanuel Robinson, Walter Cole, Ada Keyes, and Eleanor Thomas; (third row) Jimmy Corbin, D. Brandt, Charles Blalock, Joseph Richardson, John Inahern, and William Ewell.

African Americans were employed at Harrisburger Hotel as waiters, waitresses, bellhops, and janitors under African American Jimmy Harper for many years. (Courtesy Pennsylvania State Archives.)

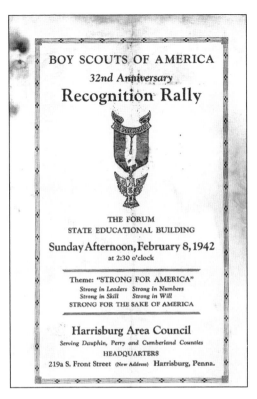

Seen at left is a booklet commemorating the 32nd anniversary of the Boy Scouts of America. Below is Oscar Watts's original Boy Scouts membership card. (Unfortunately, Oscar's last name was not spelled correctly on the card.) (Courtesy Margaret Watts Williams.)

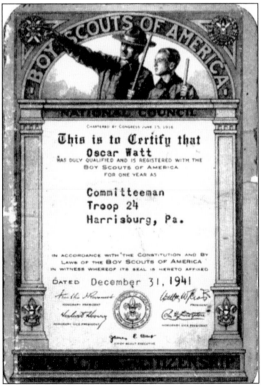

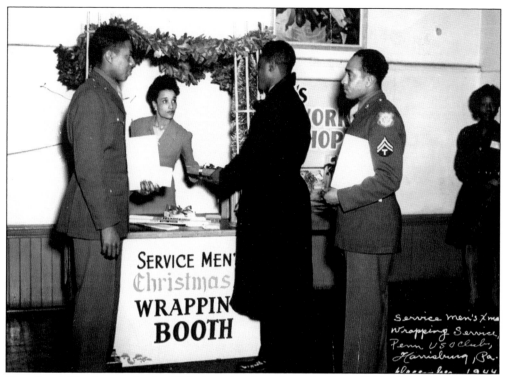

Mrs. Pearl Ward attends the USO greeting booth at the Penn USA Club is pictured in 1944. (Courtesy Margaret Watts Williams.)

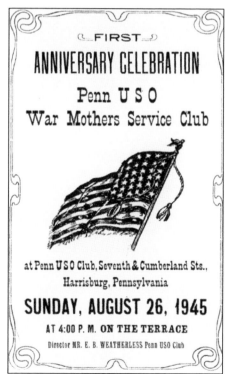

The first anniversary of the War Mothers Service Club was celebrated in 1945.

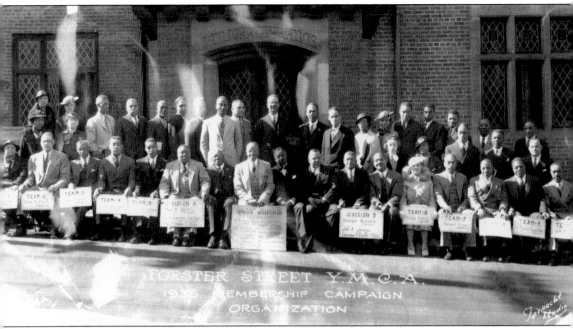

This photograph of the Forster Street YMCA Membership Campaign Committee shows, from left to right, the following: (first row) Agnes Johnson, Charles Erwin, Charles Fisher, Ivan Williams, Lorenzo Rowland, Charles Curtis, Dr. C. Lennon Carter, Sylvester Jackson (holding sign), Dr. Charles Crampton, unidentified, George Winters, Joseph James, Ruby Moore, James Green, ? Cannon, unidentified, Tallie Caution, and William ?; (second row) Ella Frazier, Susan Thomas, four unidentified, and Charles Thomas; (third row) four unidentified, Paul Washington, and 11 unidentified. On the far right is Lawrence Williams; the man to the left of Williams is identified as Mr. Strain. (Courtesy Kathryn Grigsby Butler.)

Seven

ARTS AND
ENTERTAINMENT

The May 3, 1883, issue of the *Home Journal* records the following events: the Mozart May party, held at the National Hall; the Zion Workers Reunion, held at Shakespeare Hall (well attended by people such as the Popels, William Marshall, J. Scott, Carrie Davis, G. Spotwood, and Mr. and Mrs. Thomas); dances featuring the Steelton Band; and theater presentations held in the churches and at the service organization sites.

By the beginning of the 20th century, there were many schools for music, elocution, and drama, such as the Burris Musical Studio, the Howard School, and the Lillian Ball School. Other local music teachers taught in homes, as did Vera Ghoulston. The movies were then becoming popular. In an oral history interview, Kathryn Grigsby Butler relates that her mother, being very fair, could pass for white and would go downtown to the Majestic Theater, where she was able to sit in the downstairs section. Kathryn and her father were obliged to sit in the balcony with the other African Americans. A lawsuit later changed this practice.

Jazz played a large role in the social scene, as Harrisburg was the transportation hub for most musicians from Chicago, Detroit, and Pittsburgh passing through on the way to New York, Philadelphia, Baltimore, and Washington, D.C. Jazz on Reist's Dance Boat, at Front and Walnut Streets, offered music by Fess Williams and his Royal Flush Orchestra.

Harrisburg produced many outstanding jazz musicians who played in the local saloons and hotels in the Uptown section in the 1930s. Fidge's was one site, and Marge Alexander (the daughter of the owner, George Alexander) became one of the nation's first and finest female band leaders, performing under the name Marj and Her Majors. In the 1940s, things shifted slightly when big bands, such as those headed by Cab Calloway, Jimmie Lunceford, and Count Basie, would come through and play at the Madrid (Palestra) Ballroom for dances promoted by B. U. Waters, Pat Taylor, Art Fields, and others. Many other local clubs began to flourish, and Harrisburg was leading the way in jazz on the East Coast up through the 1950s.

This 1916 edition of the *Advocate Verdict* features an item on an Odd Fellows convention.

The July 11, 1874 edition of *Our National Progress* states that this is the official organ of the State Equal Rights League and the official organ of the Odd Fellows. The editor of the paper was William Howard Day.

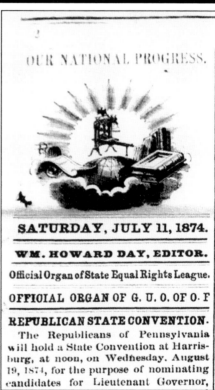

OUR NATIONAL PROGRESS.

SATURDAY, JULY 11, 1874.

WM. HOWARD DAY, EDITOR.

Official Organ of State Equal Rights League.

OFFICIAL ORGAN OF G. U. O. OF O. F

REPUBLICAN STATE CONVENTION.

The Republicans of Pennsylvania will hold a State Convention at Harrisburg, at noon, on Wednesday, August 19, 1874, for the purpose of nominating candidates for Lieutenant Governor,

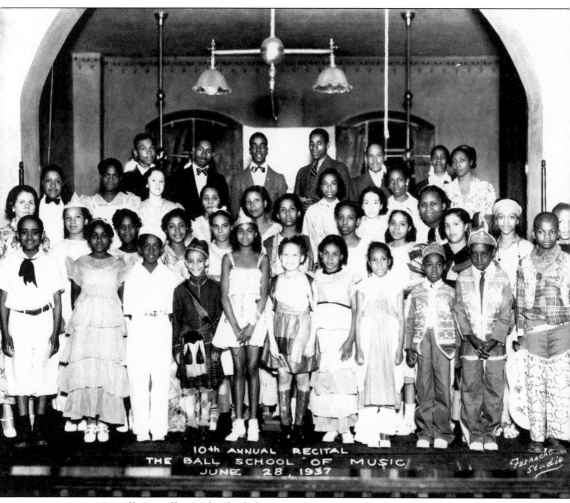

In June 1937 Lillian Ball (on the far left in second row) directed her students in a recital on the life of Johann Sebastian Bach.

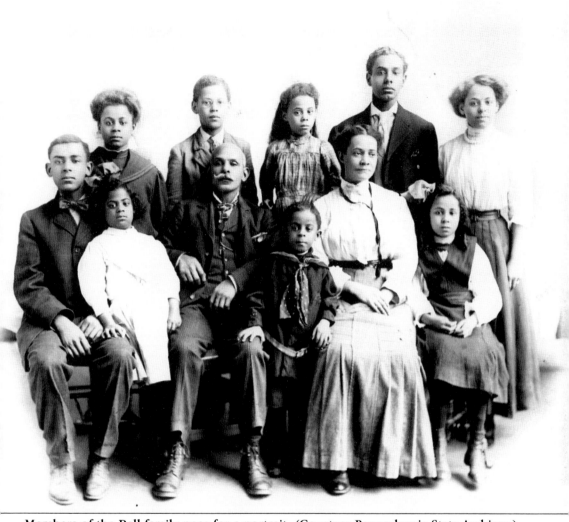

Members of the Ball family pose for a portrait. (Courtesy Pennsylvania State Archives.)

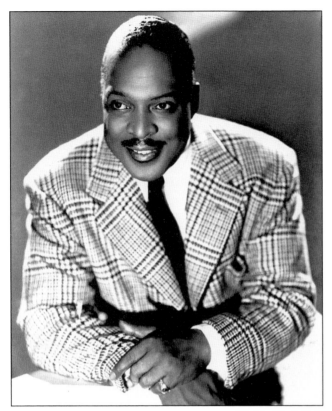

Count Basie was one of a number of great entertainers who performed in Harrisburg at the Madrid (Palestra) Ballroom and at many other venues in the area.

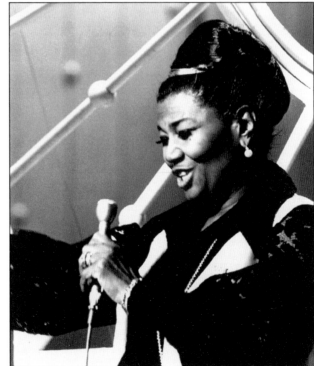

Pearl Bailey spent part of her youth in the Sibletown neighborhood and performed in Harrisburg. (Courtesy African American Museum of Philadelphia.)

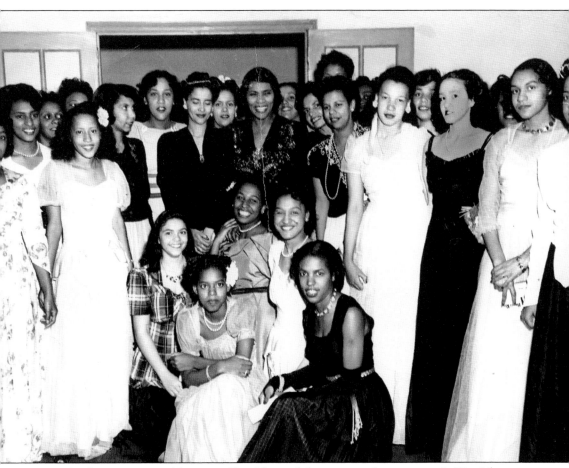

Marian Anderson poses with young Harrisburg debutantes at her concert in Harrisburg. (Courtesy Margaret Watts Williams.)

CHARLES P. McCLANE, SR.

Presents

HAZEL SCOTT

PIANIST

ASSISTED BY HER
INSTRUMENTAL TRIO

IN

CONCERT

Wednesday Evening, November 28, 1945

FORUM

8:30 P. M.
HARRISBURG, PA.

* * * *

Lawrence Golden, Management

Shown is a program for Hazel Scott's performance in Harrisburg in 1945.

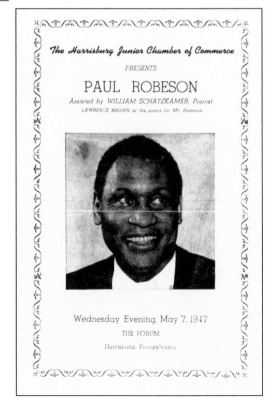

Paul Robeson's performance at the Forum in Harrisburg was sponsored by the Junior Chamber of Commerce.

The Acme Dramatic Club presented a concert by members of the National Association of Negro Musicians on August 14, 1929, at Harrisburg's Bethel AME Church.

THE ACME DRAMATIC CLUB

presents

DELEGATES TO THE CONVENTION

of the

National Association of Negro Musicians, Inc.
(August 25 - 31, Fort Worth, Texas)

in

CONCERT

WEDNESDAY, AUGUST 14th, 1929

8:15 P. M.

BETHEL A. M. E. CHURCH, Rev. J. H. L. Watkins, Pastor
Briggs & Ash Streets - Harrisburg, Pa.

Benefit of Trustee Fund

Blanche Smith-Eckles, Soprano
John Eckles, Tenor
Carl Diton, Past National President
at the Piano
} New York City

PROGRAM

Care Selve	Handel
I Came With A Song	La Forge
Jewel Song (from Faust)	Gounod
Mrs. Eckles	
Caro Mio Ben	Giordani
Vesti la Giubba (from Pagliacci)	Leoncavallo
Swing Low Sweet Chariot	Diton
Mr. Eckles	
With Verdure Clad (from The Creation)	Haydn
Un Bel Di Vedremo (from Madam Butterfly)	Puccini
Mrs. Eckles	
Comfort Ye My People (from The Messiah)	Handel
My Dreams	Tosti
Onaway, Awake Beloved (from Hiawatha)	Coleridge-Taylor
Mr. Eckles	
INTERMISSION	
La Pietra Fatal (End of Aida)	Verdi
Mr. and Mrs. Eckles	

Pictured here is a program for *The Disappointed Bride*, written by Rev. J. P. Sampson.

CONCERT
Technical High School
Tuesday Evening, May 18, 1920

Presented by Educational Committee
Y. M. C. A., Colored Men's Branch

PROGRAM

Clarence Cameron White, Violinist
Florence Cole Talbert, Soprano
Marian Anderson, Contralto
William L. King, Pianist

1 Rondo Capriccioso _____ _____ _____ _Mendelssohn
Mr. King

2 Adieu, Forets, Jeanne d'Arc_____ _Tchaikowsky
Miss Anderson

3 Symphonie Espagnole _____ _____ _____ _Lalo
Mr. White

4 Thou Brilliant Bird_____David
Mrs. Talbert

5 (a) I'm so glad trouble won't last _____ _____Dett
 (b) Peter, go ring dem Bells_____ _____ ___Burleigh
Miss Anderson

6 Bandana Sketches_____Clarence Cameron White
Four Negro Spirituals
 (a) Chant
 (b) Lament
 (c) Slave
 (d) Dance
Mr. White

7 (a) Invocation to the Sun God_____ _____ _Trayer
 (b) The Rose _____ _____ _Lieurance
Mrs. Talbert

8 (a) Traumerei _____ _____ __Schuman
 (b) Orientale_____Cui
 (c) Viennese song _____ _____ ___ ____Kreisler
 (d) Scherzo _____ _____ __Van Goens
Mr. White

9 Duet, Serenade_____ _____ _____Schubert
Mrs. Talbert and Miss Anderson

In May 1920 the YMCA Colored Branch sponsored a concert featuring Marian Anderson. The event was held at the Technical High School.

An Autumn Musicale
...By...
Dorcas Art Club
...Of...
Capital Street Presbyterian Church
Thursday Evening, October 10th, 1940

REV. VERNON JAMES	*Prayer*	
MISS SUE ALEXANDER	*Solo*	
MR. PETER GARNETT	*"Rosary"*	NEVIN
MISS ANNA CARTER	*"I Hear a Thrush at Eve"*	CADMAN
SPENCER WATTS	*Trumpet Solo—*"La Donna e Mobile"	VERDI
MR. JOE TOLIVER	*"God Bless America"*	BERLIN
MISS TAYLOR	*Solo*	
MRS. F. D. GHOLSTON	*"Fourth Mazurka"*	GODARD
MRS. RICHARD DUFFAN	*"Serenade"*	FRANZ SCHUBERT
MESDAMES WEDLOCK, DAWSON, CRUMP	*Trio*	
MR. CARL FINLEY	*"Lord's Prayer"*	A. MALOTTE
MRS. P. CANNON, MRS. EVA BRAXTON		
	"Hallelujah Chorus"	HANDEL
MISS HELEN NORRIS	*Reading*	
MRS. GRACE BULLOCK	*"Grateful Oh Lord, Am I"*	CARA ROMA
MR. JAMES HARPER	*"Ave Marie"*	SCHUBERT
MRS. C. R. FOUNTAIN	*Solo*	

Our National Anthem
Benediction

An Autumn Musicale was presented by the Art Club of the Capital Street Presbyterian Church in 1940.

Pictured is present-day Sixth Street. From left to right are the Curtis Funeral Home (formerly the Swallow Mansion), Jack's Barbershop, the Jackson House Restaurant, and the Jackson House (next to what used to be the Bethel AME Church).

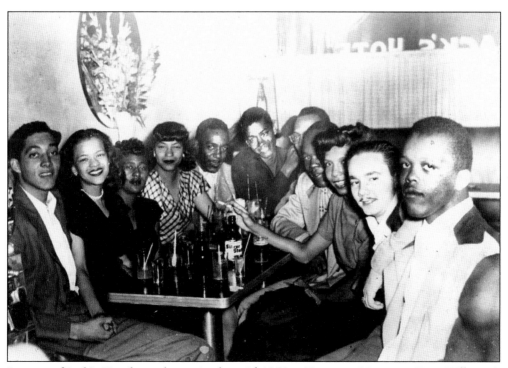

Patrons of Jack's Hotel are shown in the mid-1950s. (Courtesy Margaret Watts Williams.)

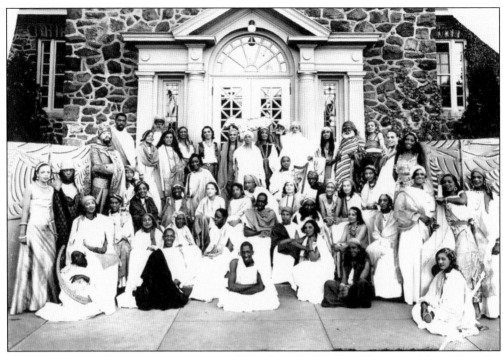

This pageant at Cheyney State Normal School included Harrisburg resident Dorothy Grigsby Duffin (far right, second row). (Courtesy Gerri Hamilton.)

Kathryn Grigsby Butler is the sister of Dorothy Grigsby Duffin.

Eight

SPORTS

According to Ted Knorr and Calobe "Jackie" Jackson in the article "Blackball in Harrisburg" (published in 1998 in the commemorative booklet for the second-annual Negro League celebration), the first game on record for a black club in Harrisburg was between the Pythian Club of Philadelphia and Harrisburg's Monrovia Baseball Club, on October 5, 1867. The first professional baseball team was the Cuban Giants (formed in 1885). Clarence Williams and Jack Frye, from Harrisburg, were on that team. The May 3, 1883 issue of the *Home Journal* lists the box score of a game played in Harrisburg: Harrisburg 14, Actives 3. It also comments that Wise and McCloskey were a formable battery and that Smith was "sure death at all balls coming his way."

By 1890, Col. William Strothers formed the Harrisburg Giants. In an oral history, Marshall Waters said, "The game was baseball, we didn't think of other sports at that time. A midget team was formed in Sibletown and a neighbor made uniforms but we never played a game."

Football was also popular, and the Harrisburg Trojans played games on City Island, where families enjoyed a day out with picnic baskets and music. The Harrisburg Lions were formed after the Trojans in the 1950s.

Dr. Bud Marshall and Dr. Gus Granger formed the Harrisburg Scholastics basketball team in the early 1900s. The Harrisburg Knights from the YMCA followed the tradition.

In 1905, the first football team of the Harrisburg Technical School was formed, and African American Layton Howard was on the team. A few years later, the Tech squad won a national championship. Many fine athletes played for Tech, including BoBo Armstrong, Russell Jackson, and John P. Scott. Others excelled in track and field.

Many excellent athletes, both male and female, hail from Harrisburg and have made their names at colleges and universities across the country and the world. Ed "Pete" Temple, who graduated from John Harris High School, became the women's coach for Tennessee State and was later the coach of the women's national and Olympic track teams.

This wedding portrait shows Jane Blalock, from Harrisburg, and Oscar Charleston.

Spotswood Poles was one of the most outstanding ballplayers for the Harrisburg Giants.

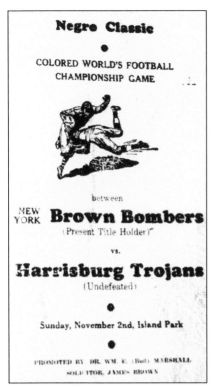

Seen is the program for the colored football world championship game, held on City Island in November 1941.

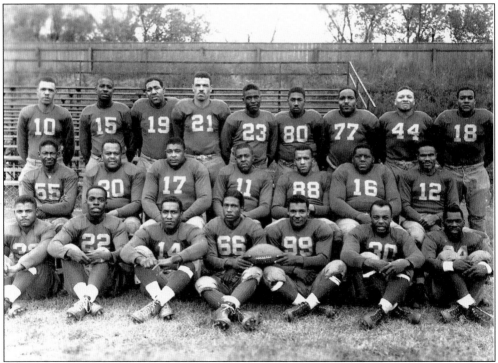

The Harrisburg Trojans pose for a team portrait on City Island. (Courtesy "Butch" Baltimore and the Mason family.)

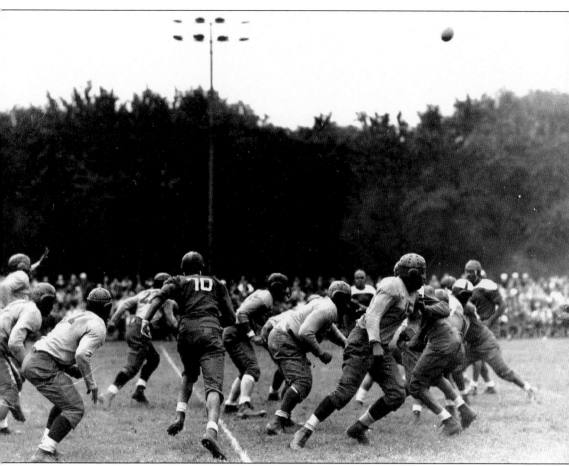

The Harrisburg Trojans are captured in an action shot taken during a game on City Island. (Courtesy "Butch" Baltimore.)

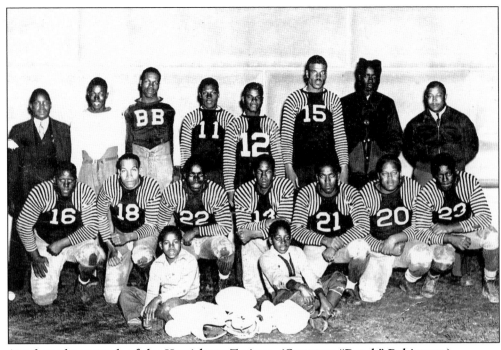

Another photograph of the Harrisburg Trojans. (Courtesy "Butch" Baltimore.)

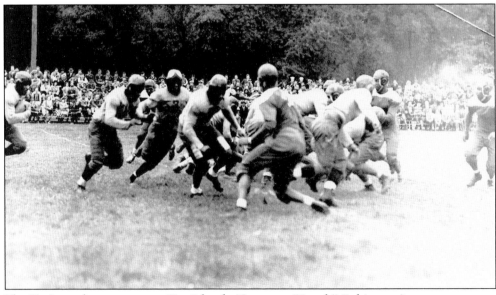

The Trojans play a game on City Island. (Courtesy "Butch" Baltimore.)

The 1941 Trojans won 39 out of their last 40 games. Members of the squad who appear in the photograph at the bottom are, from left to right, as follows: (first row) Jeff Banks (business manager), Robbie Lewis, L. Atwell, R. Hughes, Ducky Brown, H. Simpson, R. Scott, C. Brown, C. Guthrie, R. Simpson, and ? Finley (associate manager); (second row) ? Hill, J. Weathers, W. Foulkes, G. Crummel, P. Mason, G. House, W. Simpson, E. Prigg, and J. Dixon. (Courtesy "Butch" Baltimore.)

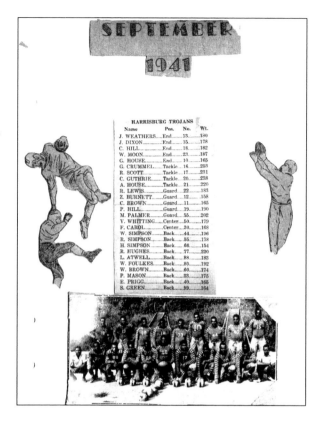

HARRISBURG TROJANS

Name	Pos.	No.	Wt.
J. WEATHERS	End	13	180
J. DIXON	End	15	178
C. HILL	End	18	182
W. MOON	End	23	187
G. HOUSE	End	10	165
G. CRUMMEL	Tackle	16	253
R. SCOTT	Tackle	17	231
C. GUTHRIE	Tackle	26	238
A. HOUSE	Tackle	21	220
R. LEWIS	Guard	22	183
Z. BURNETT	Guard	12	158
C. BROWN	Guard	11	165
P. HILL	Guard	19	190
M. PALMER	Guard	55	202
V. WHITTING	Center	50	179
F. CAROL	Center	30	168
W. SIMPSON	Back	44	196
R. SIMPSON	Back	55	178
H. SIMPSON	Back	66	154
R. HUGHES	Back	77	220
L. ATWELL	Back	88	183
W. FOULKES	Back	80	192
W. BROWN	Back	60	174
P. MASON	Back	33	175
E. PRIGG	Back	40	165
S. GREEN	Back	59	154

Some of the Trojans' cheers were used until the 1960s. Some may still be used in other regions. (Courtesy "Butch" Baltimore and the Mason family.)

109

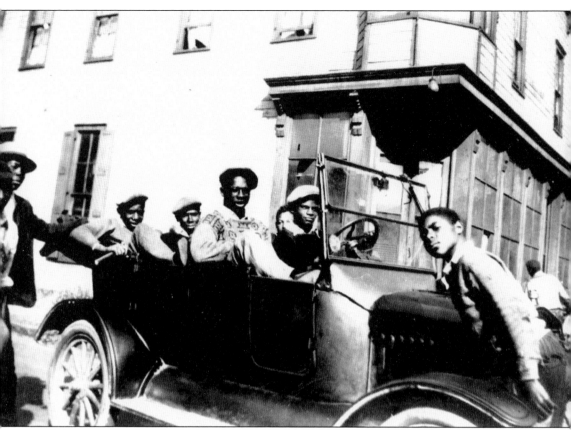

Phil Mason is at the wheel of a car he made himself. A young Dan Paige Sr. is draped across the hood. John Sturgis sits in the front passenger seat. (Courtesy Mrs. Daniel Paige Sr.)

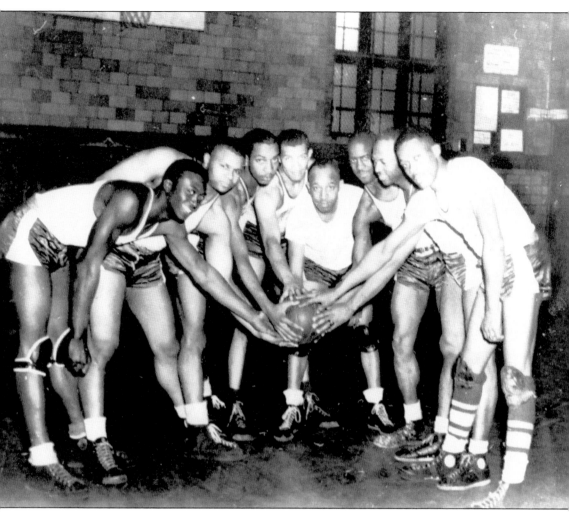

The Harrisburg Knights pose at the Forster Street YMCA in 1940. From left to right are David McWhite, Richard Felton, John "Hump" Wilkerson, Bill Scott, Harold "Doc" Hurst (coach), Henry Summers, John Sturgis, and Vince Whiting.

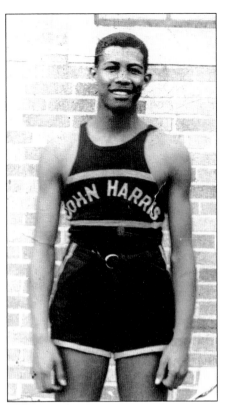

Bill Scott holds the 220-yard hurdles record at John Harris High School. He was favored at the 1933 state championship, but fell on the first hurdle. Scott was also a fine basketball player.

Henry Summers excelled in football, basketball, and track at John Harris High School in the 1930s.

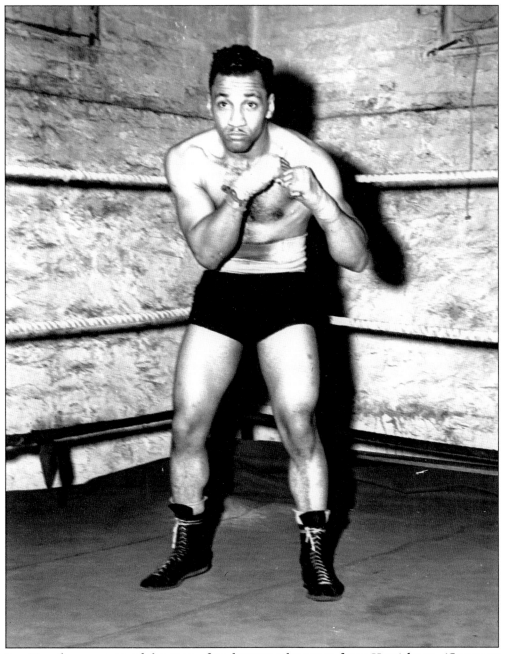

Joe Murphy was one of the many fine boxers who were from Harrisburg. (Courtesy the Mason family.)

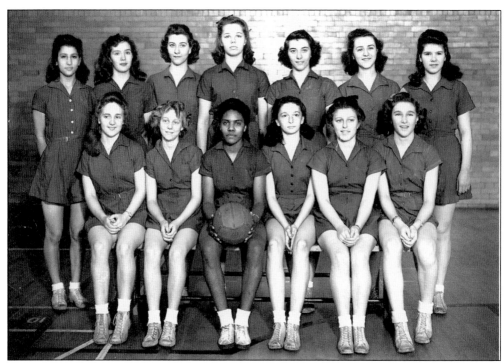

Harriet Mitchell Braxton was captain of the soccer team at William Penn High School in 1942. (She holds the ball in the center of the photograph.) Harriet also excelled in basketball, track and field, and other athletic events. (Courtesy Harriet Braxton.)

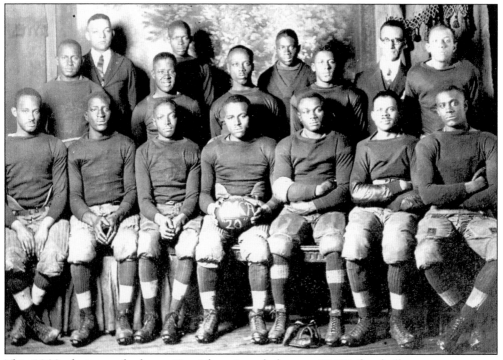

This 1920 photograph shows Harrisburg's only known YMCA football team.

Nine

EIGHT GENERATIONS OF THE WATERS AND SCOTT FAMILIES

Jennie Jones was born in 1860 in Lewisburg to a family of Caucasian and Native American descent. She wed Selinsgrove resident Charles Smith, who was of African American and Native American descent. From this marriage were born three children: George Stokes Smith, Frank Chambers Smith, and Miriam Alyce Smith. Miriam wed Philadelphian Burnett Uzziel Waters and had four children: Marian J., Thomas, Sylvia, and Stokes. Marian married William Barbour Scott, and seven children were conceived through this bond: William B., Joyce A., John W., Brenda A., Marcia E., Cynthia L., and Lynn M.

William Barbour Scott was the great-grandson of Isaac and Sarah Scott. Isaac was listed in the 1810 federal census as head of the household in Londonderry Township, Dauphin County, near Harrisburg. Isaac and Sarah's son George had three children to his second wife, Rebecca Ferguson Scott, who was from Blairsville, Allegheny County, in western Pennsylvania. The children were George R., John P., and Martha—all born in Chambersburg, 50 miles from Harrisburg. John P. wed Estella Harris, who was from Bedford, in the western part of Pennsylvania. Their five children were William B. (who wed Marian Waters), Rebecca (first born), John P., Estelle, and James Lamec.

Joyce A. Scott (the daughter of Marian and William B. Scott) married James Parker, and they had Michael and Michelle, who went on to have children of their own. Michael and wife Pat named their two girls Chantelle and Shaena; Michael's adopted son was Reginald. Chantelle's daughter Chantea was the eighth generation, after Kacy Joyce, the daughter of Michelle and Chris Howard, and Ebony's two daughters, Destine and Kiara.

The generations of the Scott and Waters families are as follows:

 I. Isaac & Sarah Scott.
 II. George Scott & Rebecca Ferguson; Charles Smith & Jennie Jones; Burnett Waters & Cinderella Hall.
 III. John P. Scott & Estella Harris; Burnett U. Waters & Miriam Smith.
 IV. William B. Scott & Marian J. Waters.
 V. William B. Scott Jr. & Anna M. Davis; Joyce A. Scott & James H. Parker.
 VI. William B. Scott III & Celestine Thomas; Michael J. Parker & Patricia Carrier.
 VII. Ebony Scott; Chantelle Parker.
 VIII. Destine and Kiara Burnett; Chantea Parker.

Jennie Jones Smith ("Nana") represents the
second generation.

Charles Smith was the husband
of Jennie Jones Smith.

Burnett Uzziel Waters was a member of the second generation.

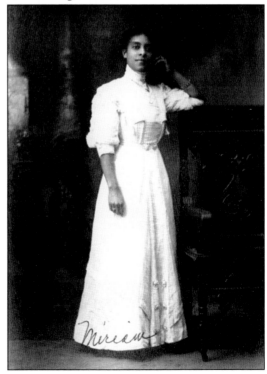

Miriam Smith Waters was the wife of
Burnett U. Waters.

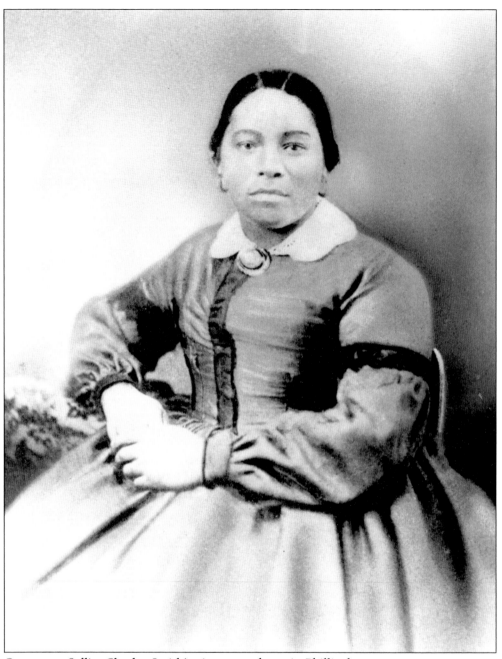

Great-aunt Sallie, Charles Smith's sister, was born in Phillipsburg.

William B. Scott (right), son of Prof. John P. Scott, was a member of the fourth generation of Scotts.

At left is Marian J. Waters Scott, the wife of William B. Scott.

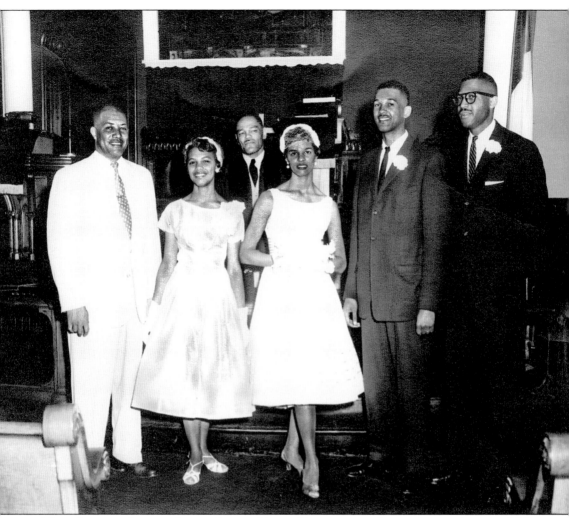

This photograph was taken at the wedding of James H. Parker and Joyce Scott (a fifth-generation Scott), the daughter of William and Marian Scott. From left to right are the bride's father, William B. Scott; the bride's sister, Brenda Alice Scott; the Reverend Clements; the bride, Joyce Scott Parker; the groom, James H. Parker; and the best man, Casper Lonesome.

Michael Parker (a sixth-generation Scott) and wife Patricia are shown with their children, Shaena (seated), Chantelle (standing, left), and Reginald Carrier Parker. (Courtesy Joyce A. Parker.)

Four generations are shown here. From left to right are Joyce (Scott) Parker; her mother, Marian (Waters) Scott; and Joyce's daughter, Michele (Parker) Howard, holding her baby, Kacy Howard.

Marian (Waters) Scott is at the center of this multigenerational photograph. Pictured with her are, from left to right, Marian's great-granddaughter Aliyah, who is held by her mother, Lisa (granddaughter of Marian); great-granddaughter Tiffani (also Lisa's daughter); and Marian's daughter Marcia (Scott) Kilgore, who is Lisa's mother.

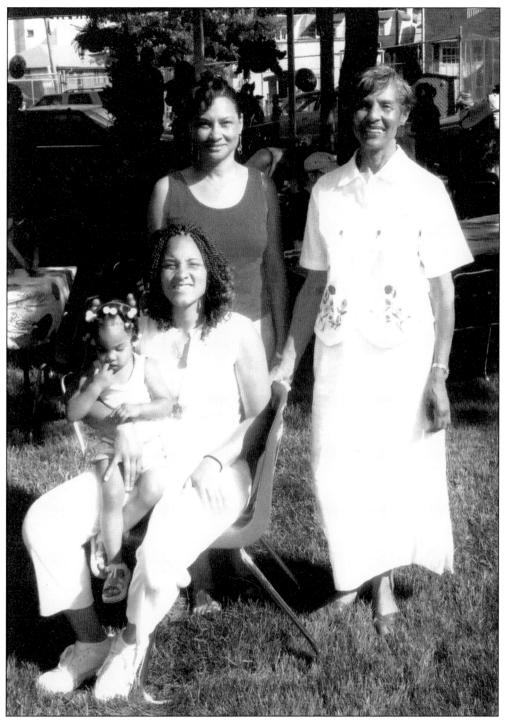

The four generations seen here are, from left to right, baby Chantea (eighth generation), who is seated with her mother, Chantelle; Patricia (Carrier) Parker, who is Chantelle's mother and wife of Michael Parker; and Chantelle's grandmother, Joyce Scott Parker, mother of Michael Parker.

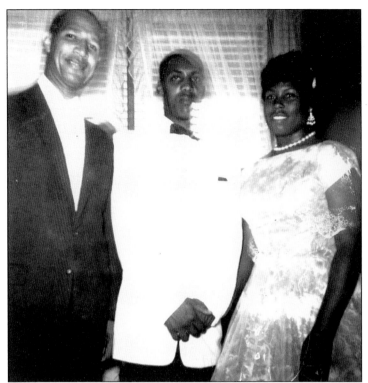

This photograph was taken in August 1959, at the wedding of William B. Scott Jr. and Anna Mae Davis Scott. From left to right are James L. Scott Sr. (the groom's uncle), groom William B. Scott Jr., and bride Anna Scott. William and Anna are the great-grandparents of eighth-generation children Destine Burnett (pictured below) and Kiara Burnett (not shown).

Destine Burnett is the daughter of Ebony Scott.

Prof. John P. Scott is shown with his five children. From left to right are Estelle, John Paul, James Lamec (on his father's lap), Rebecca (the eldest), and William Barbour (seated).

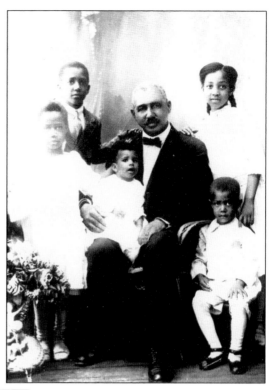

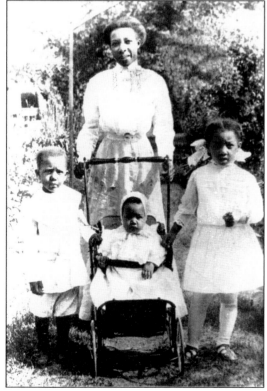

This photograph includes Estella Harris Scott, the wife of Prof. John P. Scott. The children are, from left to right, John Paul (second born), Estelle (third born, in walker), and Rebecca.

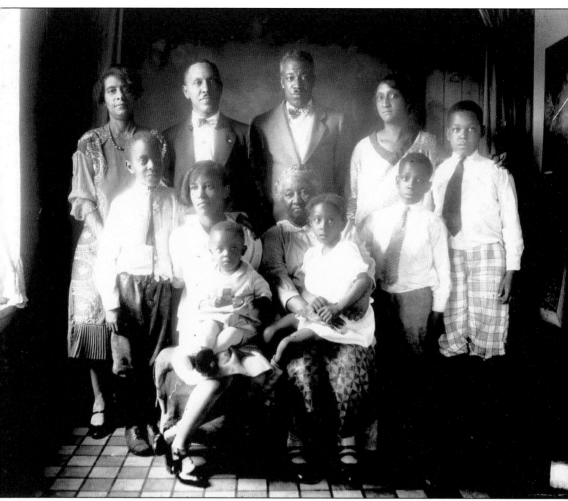

Burnett U. Waters (second from left, back row) poses with his family. From left to right are the following: (front row) Burnett's son Thomas (standing), daughter Marian (seated), son Stokes (on Marian's lap), mother Cinderella, daughter Sylvia (on her grandmother's lap), and nephew Jim (son of Burnett's brother Thomas); (back row) Burnett's wife Miriam Waters, Burnett, brother Thomas Waters, sister-in-law Bessie (wife of Thomas), and nephew Thomas Jr. (son of Bessie and Thomas).

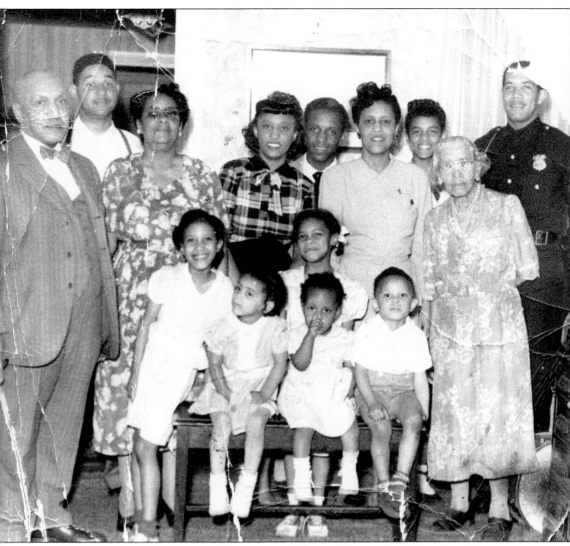

Four generations are represented here. From left to right are the following: (first row, children seated) Marcia Scott, Cynthia Scott, and Joseph Stevenson Jr.; (second row, children standing) Sandra Stevenson and Brenda Scott; (third row) Burnett U. Waters, Joe Stevenson Sr., Miriam Waters, Sylvia Stevenson, Stokes Waters, Marian Scott, Joyce Scott, Jennie Smith (known as "Nana"), and William B. Scott.

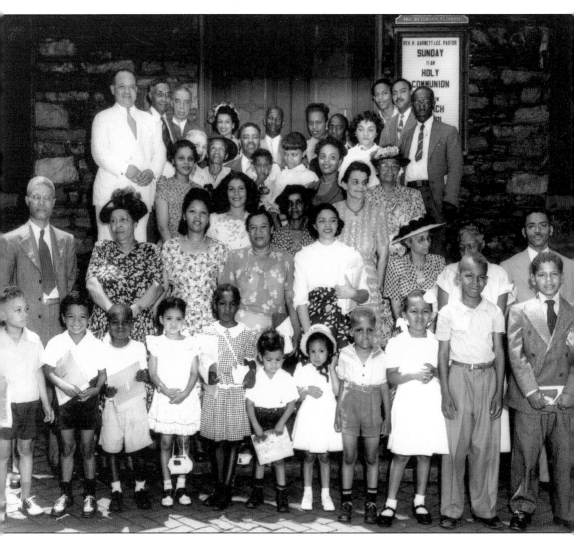

Parishioners from the Capital Street Presbyterian Church assemble in front of the old church at Capital and Forster Streets with Rev. Garnett Lee (far right, second row). From left to right are the following: (first row) Eric Woods, Lance Ulen, Tim Hargis, Karen Blalock, unidentified girl, Tony Ulen, Gwendolyn Lee, Bobby Smith, Florence Jones, Jackie Malloy, and John Frye; (second row) Harvey Reynolds D.D.S., Mrs. Alma Berry, Adelaide Smith, Mrs. Jones, Mary Braxton, Mrs. Veda Robinson, Mrs. Scoggins, and Rev. Lee; (third row) Eleanor Campbell, Connie Frye, Jennie Cooper, and Mrs. Marion Taylor; (fourth row) Mrs. White, Mrs. Lizzie Wilson, Karen Hargis, Charlotte Robinson, Cecilia Hargis, and Mrs. Washington; (fifth row) Charles G. Thomas, Armon Compton, Eva Braxton, and Ross Cooper; (sixth row) Leonard Williams, Mrs. Adley, Bernice Lee, Clifford Brock, Ruth Summers, Henry Summers, Booker Sanford, and Stewart Robinson. (Courtesy Mary Braxton.)